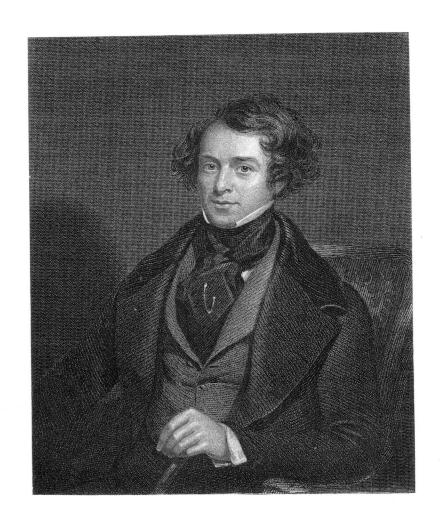

PORTRAIT OF W. H. BARTLETT

BARTLETT'S CLASSIC ILLUSTRATIONS OF AMERICA

All 121 Engravings from *American Scenery*, 1840

W. H. Bartlett

DOVER PUBLICATIONS, INC.
Mineola, New York

Bibliographical Note

This Dover edition, first published in 2000, is a collection of reproductions of all 121 of the engravings contained in Volumes I and II of the work *American Scenery: Or, Land, Lake and River Illustrations of Transatlantic Nature*, originally published in 1840 by George Virtue, London. A new introductory Note has been specially prepared for this edition.

DOVER *Pictorial Archive* SERIES

Library of Congress Cataloging-in-Publication Data

Bartlett, W. H. (William Henry), 1809–1854.
 Bartlett's classic illustrations of American scenery, 1840 : all 121 engravings from American scenery, 1840 / W.H. Bartlett.—Dover ed.
 p. cm. — (Dover pictorial archive series)
 Rev. ed. of: Americal scenery / Nathaniel Parker Willis. 1st ed. 1840.
 This edition is a collection of reproductions of all 121 of the engravings contained in vols. I and II of the work American scenery.
 ISBN 0-486-41221-0 (pbk.)
 1. United States—Description and travel. 2. United States—Pictorial works. 3. Landscape—United States—History—19th century—Pictorial works. 4. Engraving, American. I. Title: Classic illustrations of American scenery, 1840. II. Willis, Nathaniel Parker, 1806–1867. American scenery. III. Title. IV. Series.

E165 .B37 2000
769'.43673—dc21

99-056539

Manufactured in the United States of America
Dover Publications, Inc., 31 East 2nd Street, Mineola, N.Y. 11501

Note

Either Nature has wrought with a bolder hand in America, or the effect of long continued cultivation on scenery, as exemplified in Europe, is greater than is usually supposed. Certain it is that the rivers, the forests, the unshorn mountain-sides and unbridged chasms of that vast country, are of a character peculiar to America alone—a lavish and large-featured sublimity . . . quite dissimilar to the picturesque of all other countries.
—N. P. Willis, Esq., from the Preface
to the original edition of *American Scenery*

The book these engravings are gleaned from—*American Scenery: Or, Land, Lake and River Illustrations of Transatlantic Nature*—is an American-British co-production and one of the finest examples of the "travelogues" on America which were part of a growing trend that began in the 1820s, and reached its height during the 30s and 40s. The movement was fueled in part by cosmopolitan, well-to-do Europeans whose mania for traveling demanded new vistas for their tourist dollars, and in part by the popularity of landscape gardening and painting, particularly in England. In Europe and the Old World, the emphasis was on the past, where external objects (castles, cathedrals, etc.) were embodiments of the historical and the legendary. In contrast, America represented the future in all its untrammeled glory, and Europeans were invigorated by its fresh, new outlook. Travel itineraries became uniform to a point, and in fact, the views in *American Scenery* dovetail nicely with the "American Grand Tour": from the Hudson River to the Catskills, along the Erie Canal to Niagara Falls, and back through the White Mountains and the Connecticut Valley. Sites especially favored by European tourists were the Philadelphia Water Works (Plate 103)—generally regarded as "among the most noble public undertakings of the world," an artful example of nature harnessed to serve man—and Niagara Falls and environs (Plates 2, 6, 8, 13, 16, 46, and 73), where untamed nature reigned supreme.

Of all the views contained herein, there is probably only one that is likely to baffle most modern readers: Plate 36, the "Willey House, White Mountains" in New Hampshire. The "Willey House" as it was known to "all readers of newspapers" concerned the terrible twist of fate that befell a family of nine who lived in the Notch of the White Mountains. One night after the family had retired to their beds they were suddenly awakened by a rumbling noise of increasingly violent intensity that emanated from the mountains. They took flight from their house in a frenzied effort to escape what sounded like impending doom—"a vast mass of earth and rocks, disengaged from the precipices above them, suddenly rushed down the side of the mountain." The irony was that while the landslide "swept every thing before it, [it] divided in the rear of the house, reunited again, leaving it unharmed, and thundered down to the valley, overwhelming the fugitive family" in its wake. There were no survivors.

The writer of the text* that accompanies the engravings, N[athaniel] P[arker] Willis (1806–1867) was, during his time, the most famous American man of letters abroad (with the exception of Washington Irving and James Fenimore Cooper), and so an apt choice for narrator of *American Scenery*. He was a poet, journalist, editor and dramatist, who earned the admiration and close friendship of Edgar Allan Poe. New York City was Willis' stomping grounds, and one contemporary remarked of him that he was "the topmost bright bubble on the wave of the Town." In the course of his travels for the book, Willis happened upon the "Glenmary" estate (Plate 111), which he purchased and made his country home for a time.

The British cast of *American Scenery* included the outstanding topographical draftsman, W[illiam] H[enry] Bartlett (1809–1854), who excelled at landscape and scenic effects, and George Virtue (1793?–1868) the London publisher of this distinguished collection who, in the course of his illustrious career, issued upwards of 20,000 copper-and-steel engravings. Virtue was famous for selecting only the most accomplished artists and the finest engravers for the books he produced, and the quality of *American Scenery* exemplifies his high standards.

*The current volume does *not* include the text; it is a reprint of the engravings exclusively.

Contents

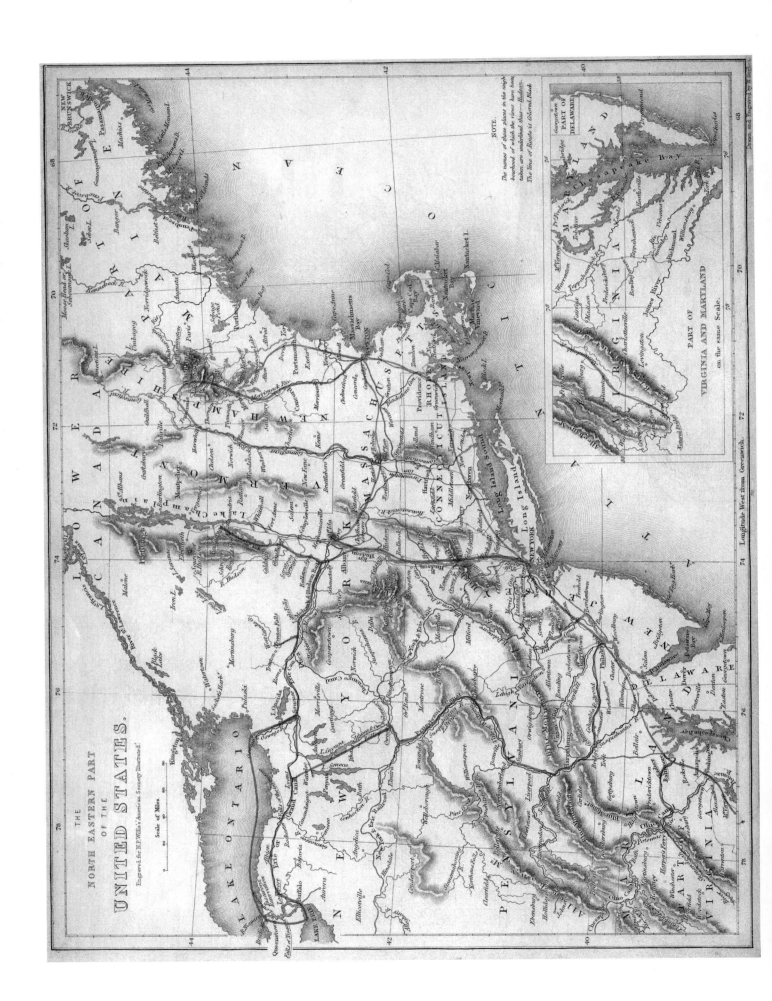

THE
NORTH EASTERN PART
OF THE
UNITED STATES.
Engraved for N.P. Willis's American Scenery Illustrated

Scale of Miles

PART OF
VIRGINIA AND MARYLAND
on the same Scale.

PART OF
DELAWARE

NOTE.
The names of those places in the neighbourhood of which the river have been taken, are underlined thus—Hudson.
The line of Route is Colored Black.

Longitude West from Greenwich

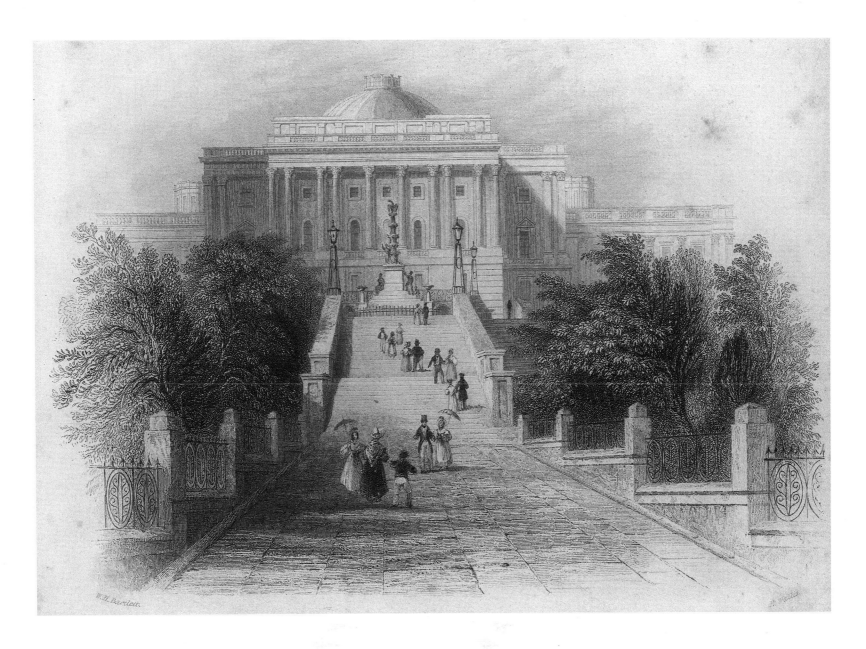

1. ASCENT TO THE CAPITOL, WASHINGTON

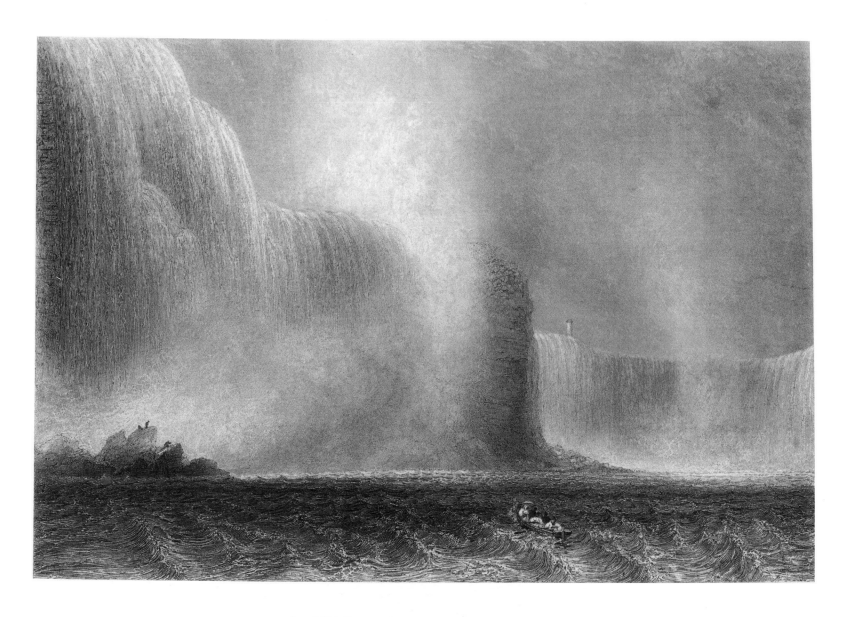

2. NIAGARA FALLS FROM THE FERRY

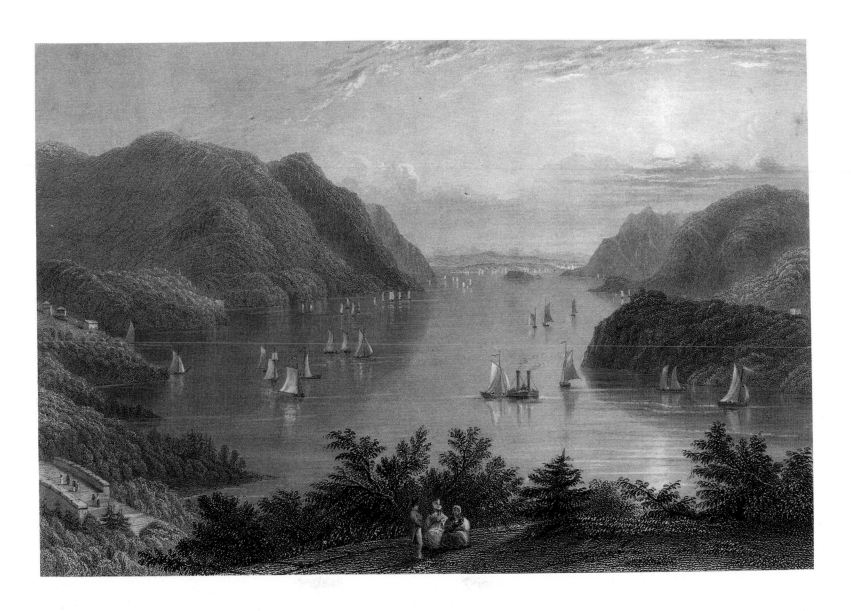

3. VIEW FROM WEST POINT

(HUDSON RIVER)

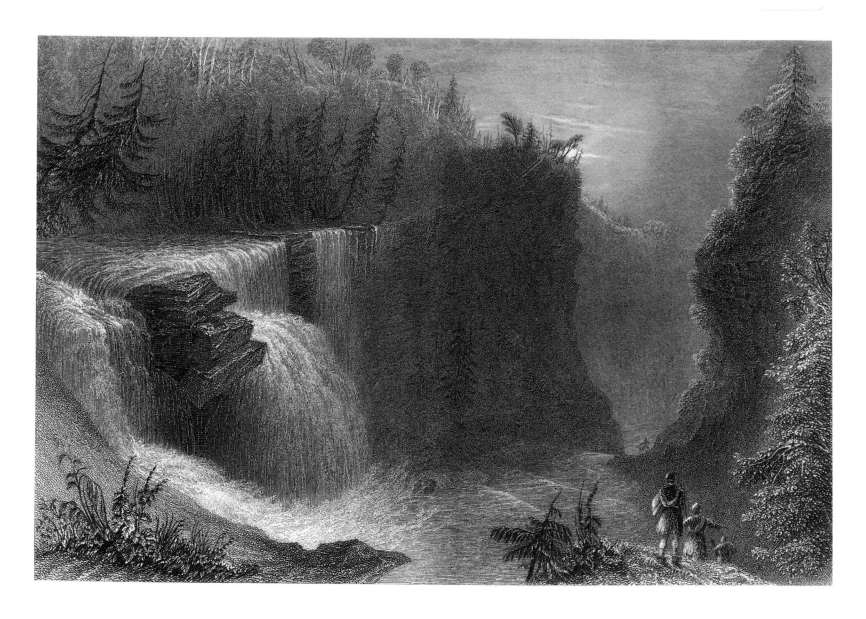

4. TRENTON FALLS, VIEW DOWN THE RAVINE

(NEW YORK)

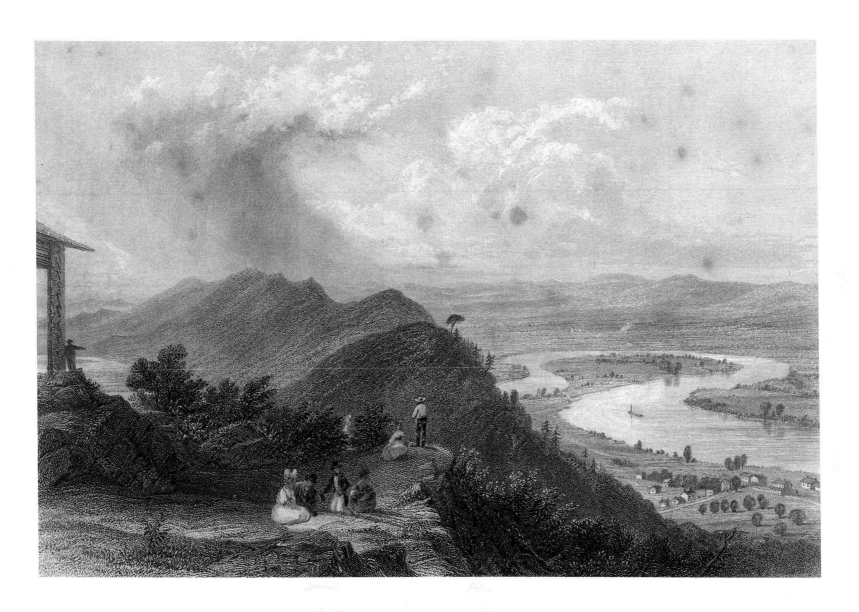

5. VIEW FROM MOUNT HOLYOKE

(MASSACHUSETTS)

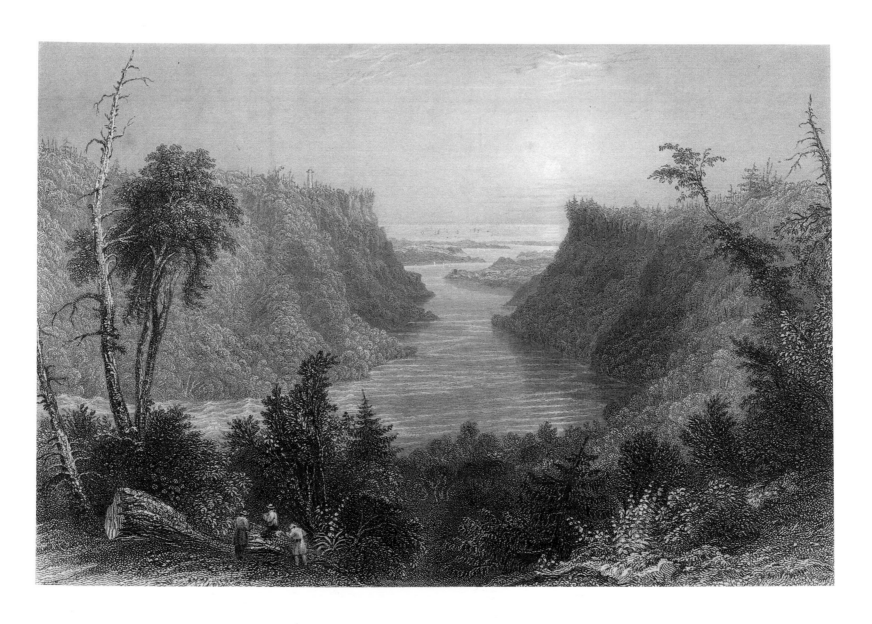

6. THE OUTLET OF THE NIAGARA RIVER

(LAKE ONTARIO IN THE DISTANCE)

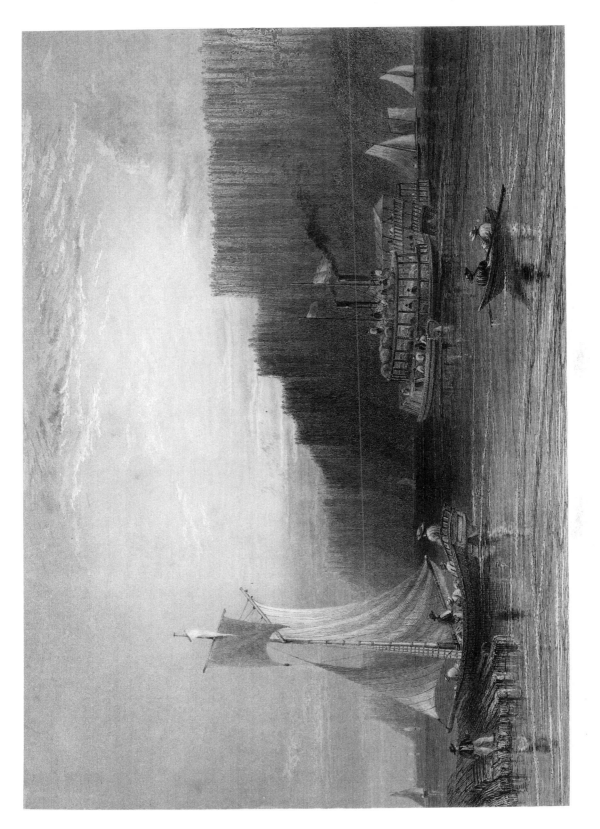

7. THE PALISADES—HUDSON RIVER

(NEW JERSEY)

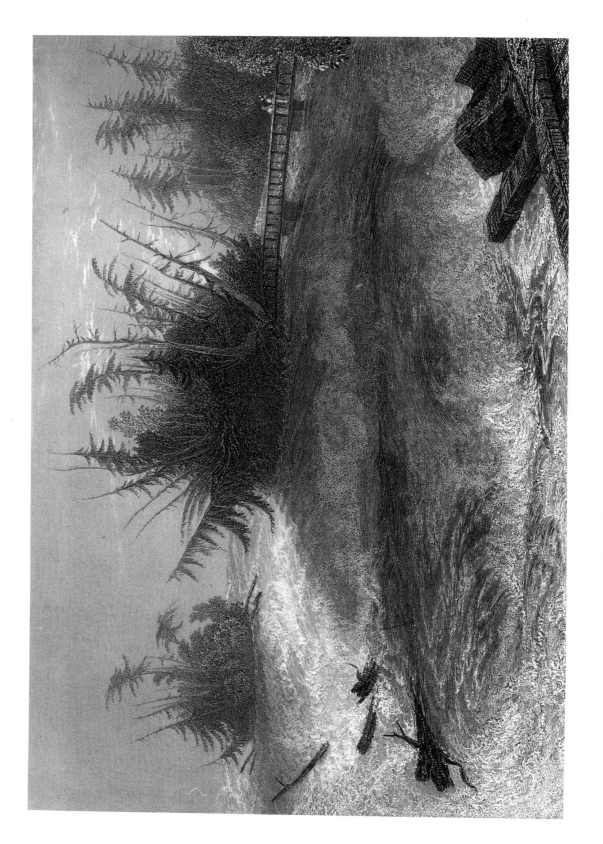

8. THE RAPIDS ABOVE THE FALLS OF NIAGARA

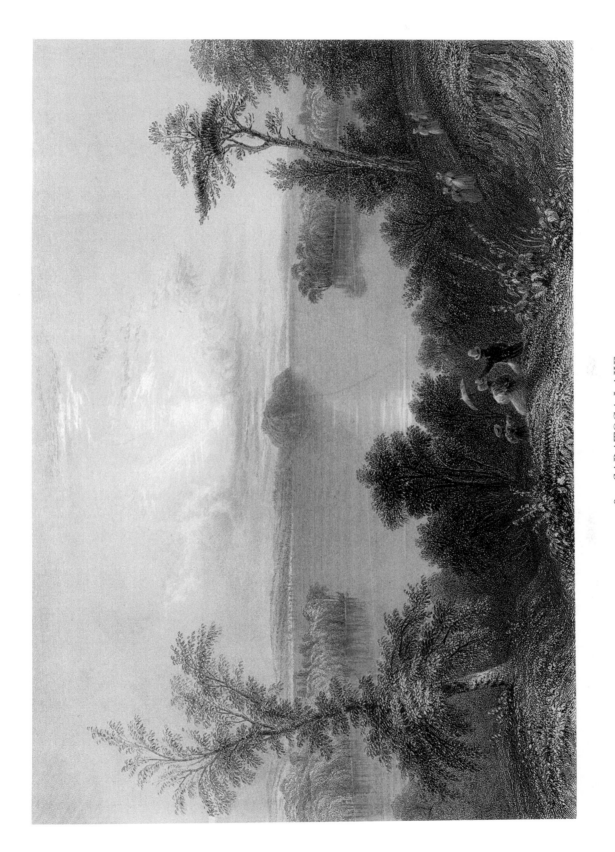

9. SARATOGA LAKE
(NEW YORK)

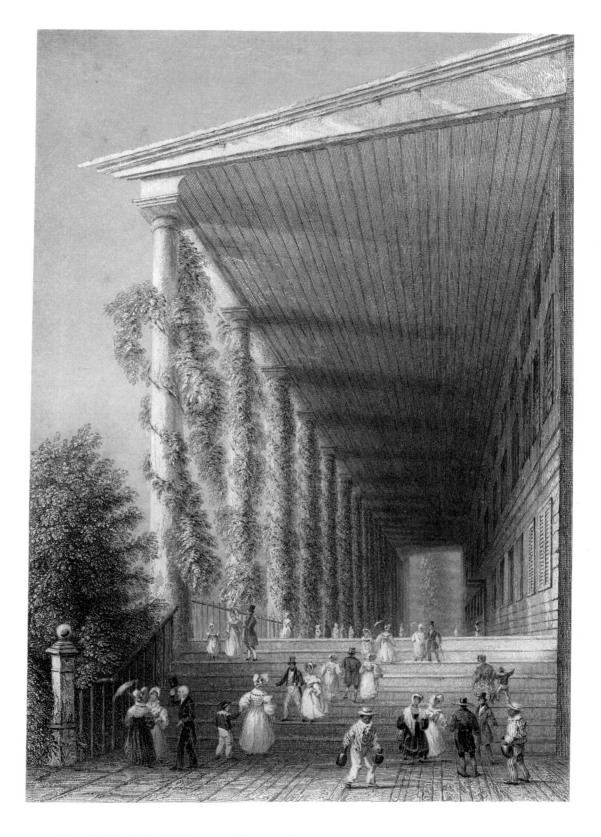

10. THE COLONNADE OF CONGRESS HALL, SARATOGA SPRINGS

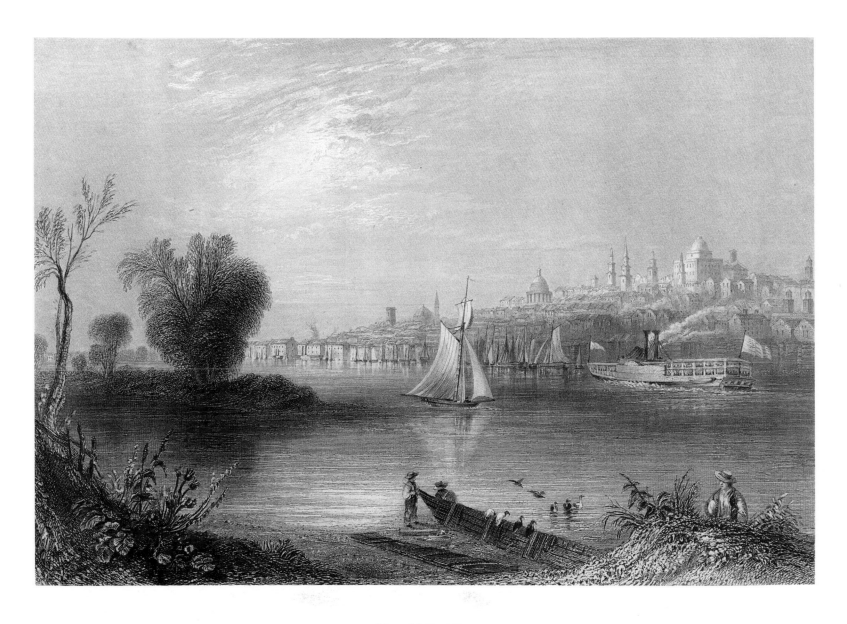

11. ALBANY

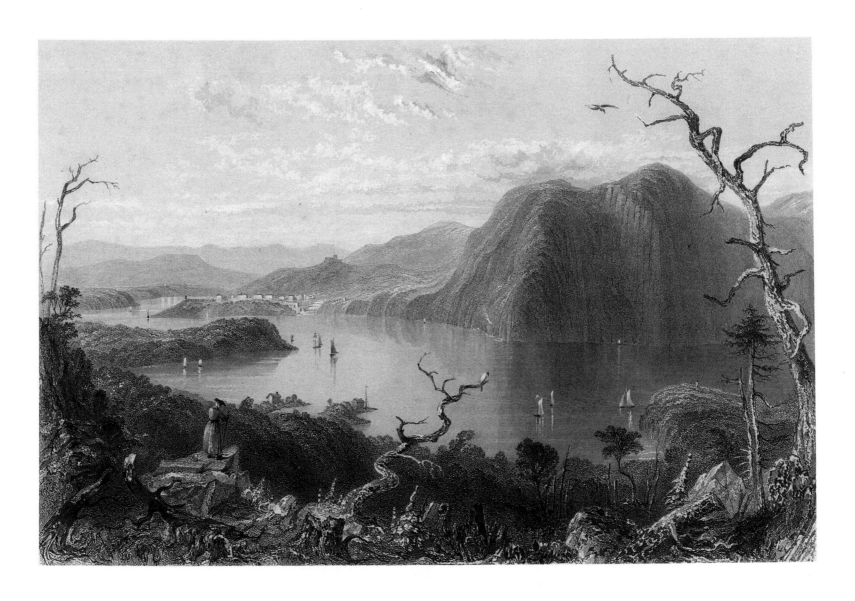

12. CROW'S NEST, FROM BULL HILL, WEST POINT

(HUDSON RIVER)

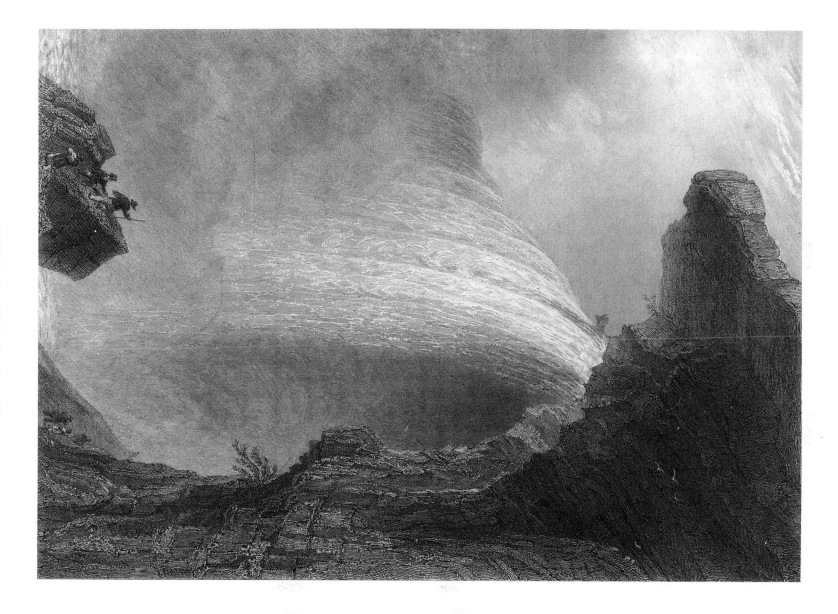

13. VIEW BELOW TABLE ROCK

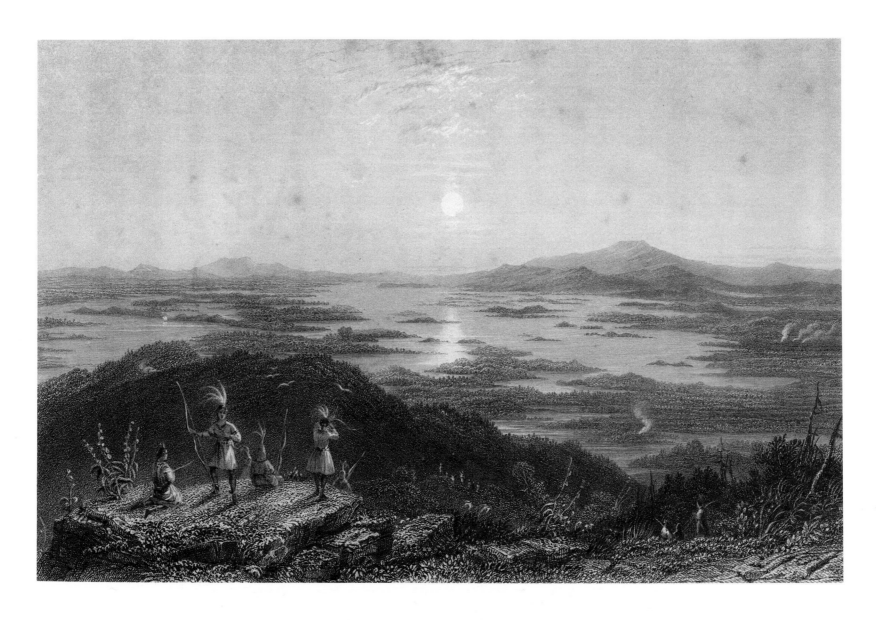

14. LAKE WINNIPESAUKEE, NEW HAMPSHIRE, FROM RED HILL

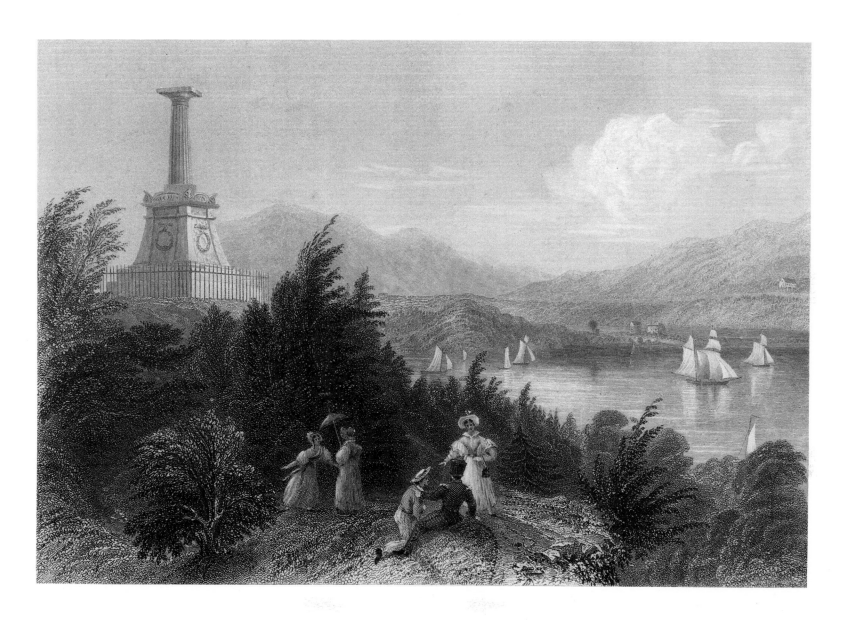

15. THE TOMB OF KOSCIUSKO

(WEST POINT)

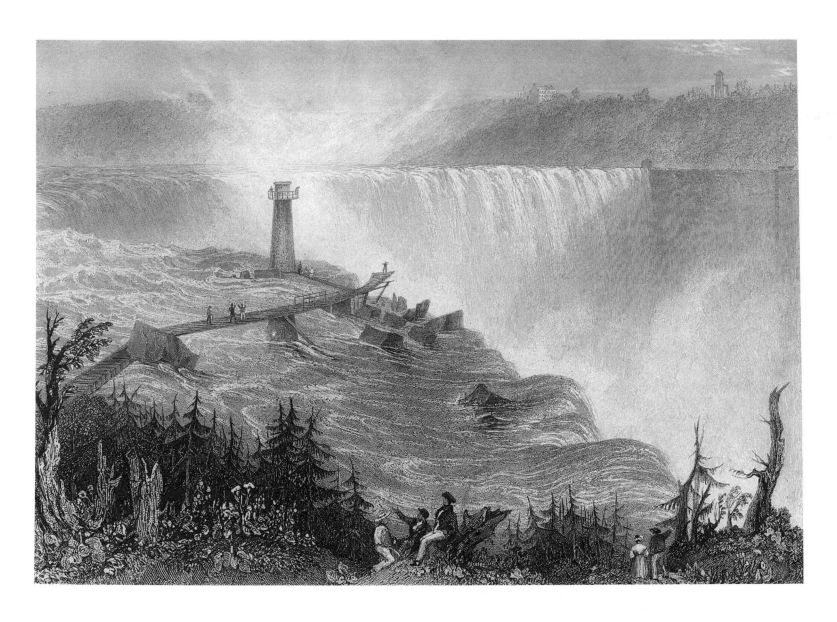

16. THE HORSESHOE FALLS AT NIAGARA—WITH THE TOWER

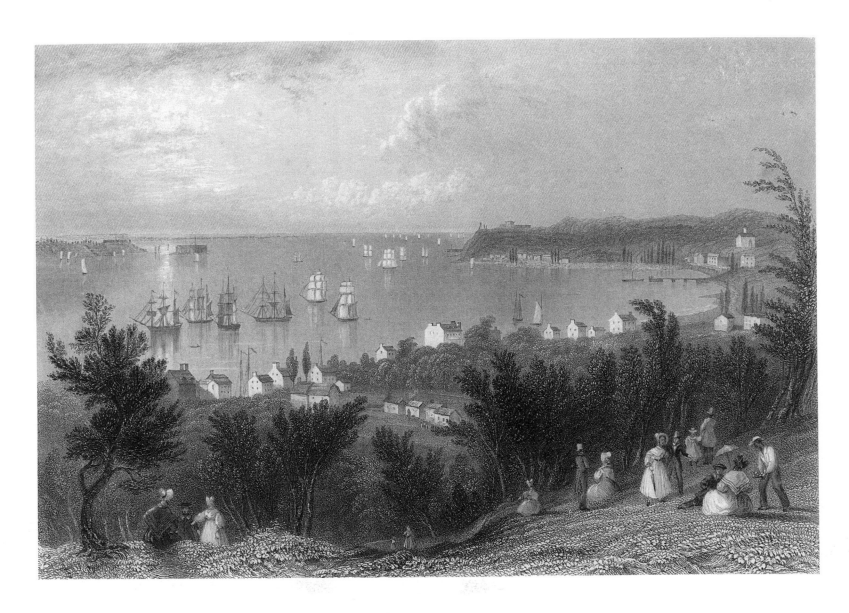

17. THE NARROWS, FROM STATEN ISLAND

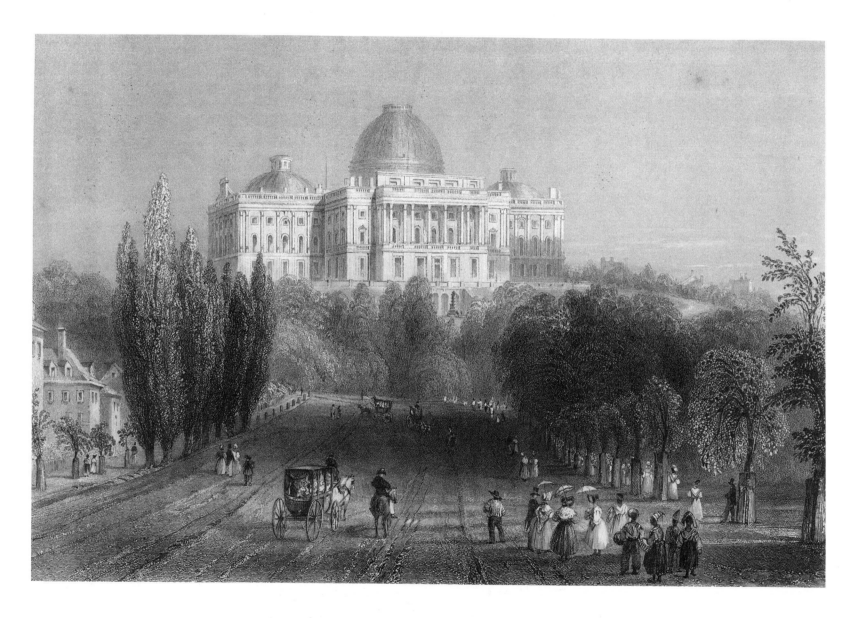

18.　VIEW OF THE CAPITOL AT WASHINGTON

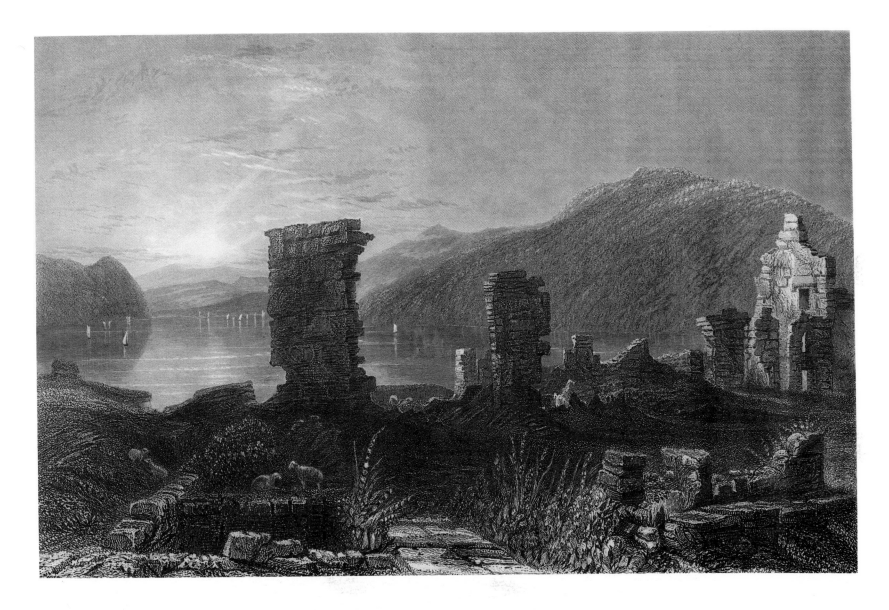

19. VIEW OF THE RUINS OF FORT TICONDEROGA

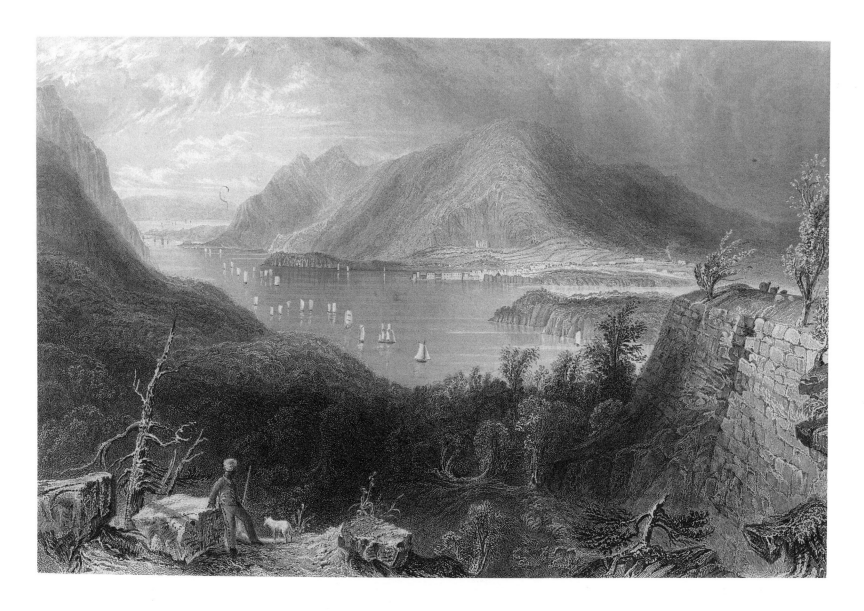

20. VIEW FROM FORT PUTNAM

(HUDSON RIVER)

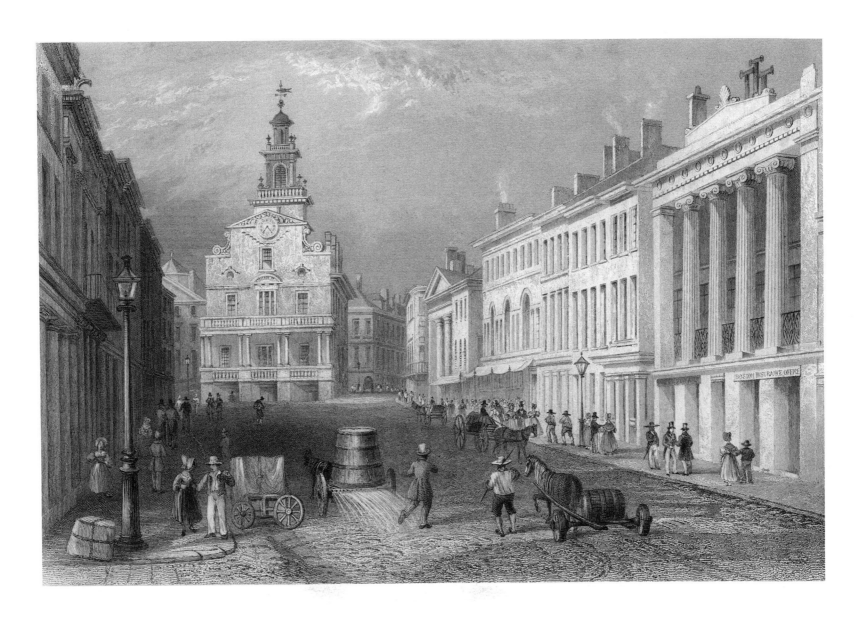

21. VIEW OF STATE STREET, BOSTON

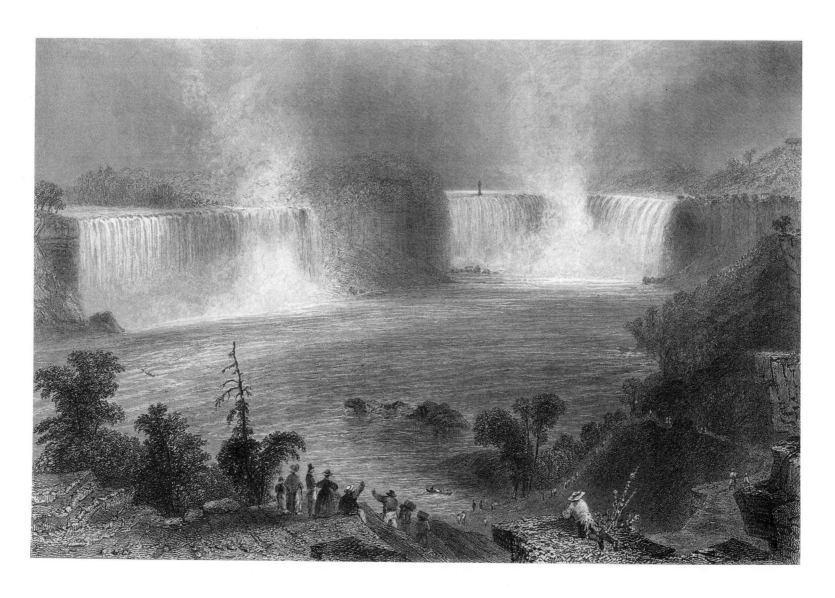

22. NIAGARA FALLS

(FROM NEAR CLIFTON HOUSE)

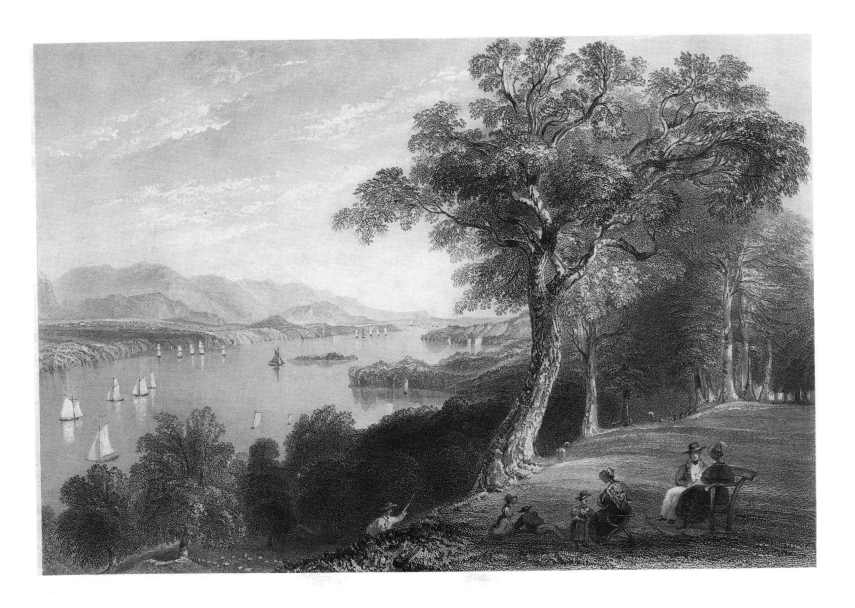

23. VIEW FROM HYDE PARK

(HUDSON RIVER)

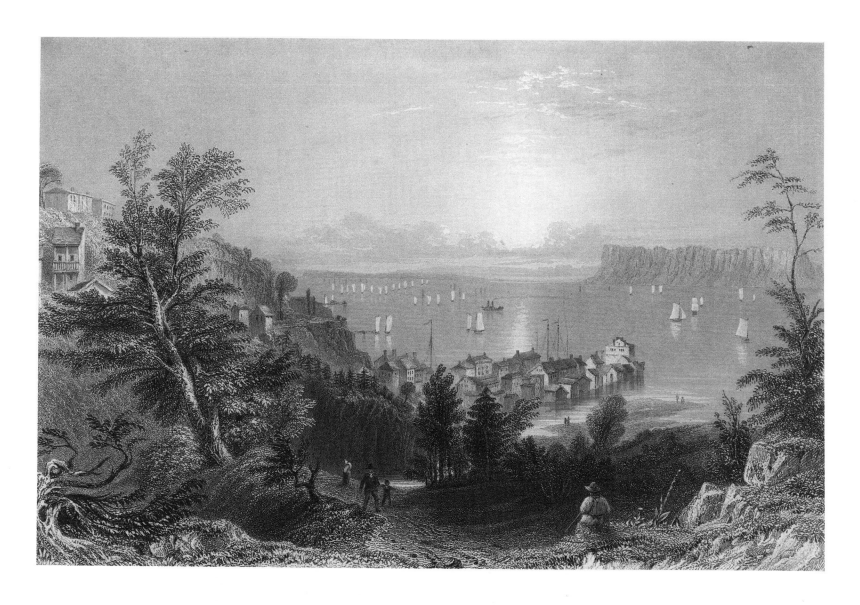

24. VILLAGE OF SING-SING

(HUDSON RIVER)

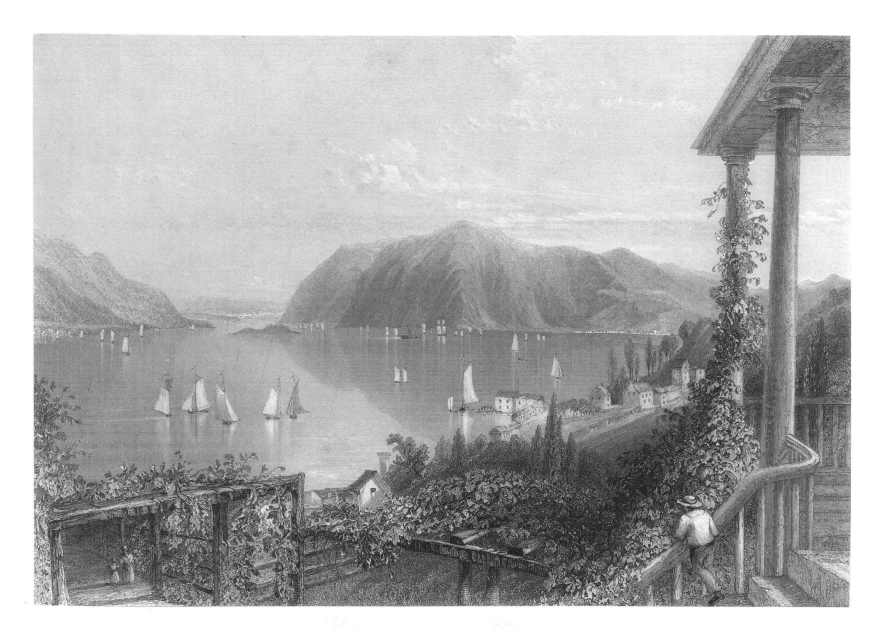

25. VIEW FROM RUGGLE'S HOUSE, NEWBURGH

(HUDSON RIVER)

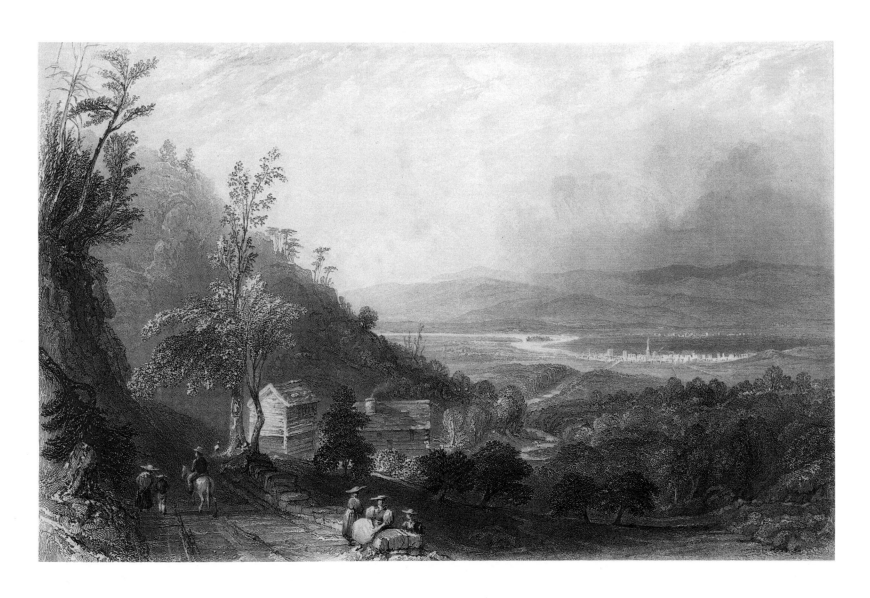

26. DESCENT INTO THE VALLEY OF WYOMING

(PENNSYLVANIA)

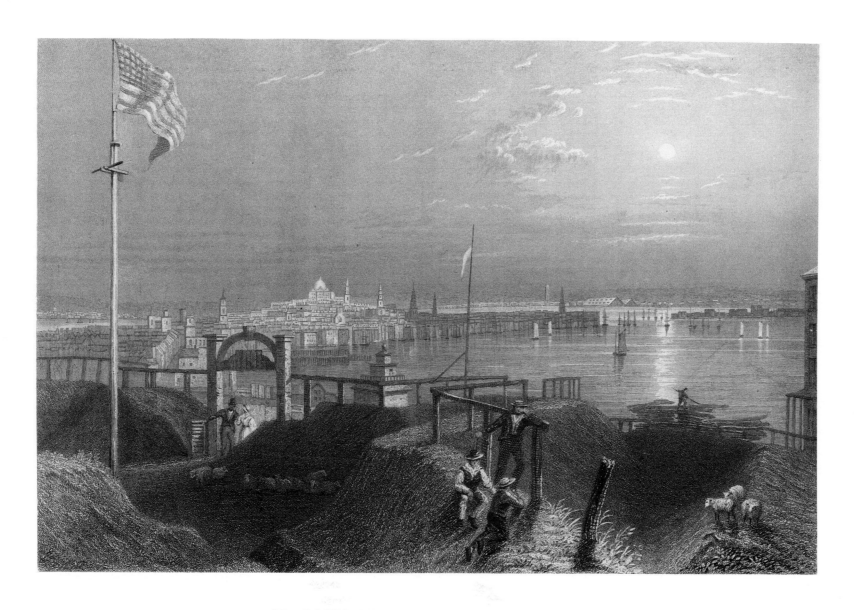

27. BOSTON, FROM DORCHESTER HEIGHTS

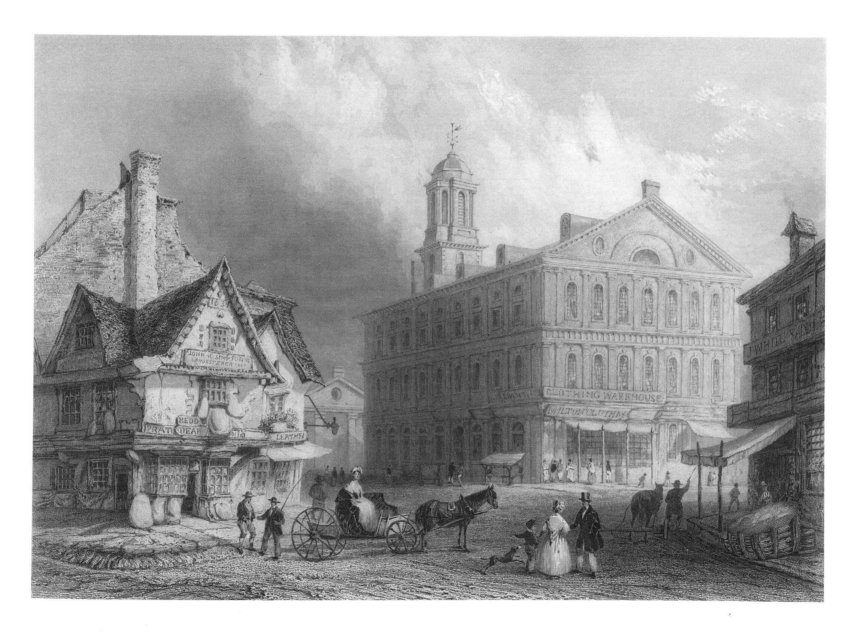

28. VIEW OF FANEUIL HALL, BOSTON

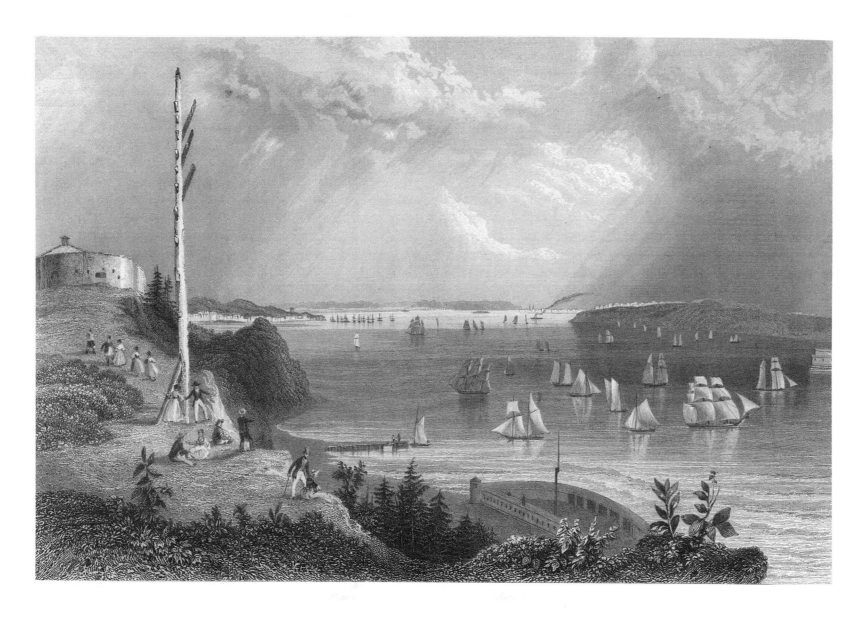

29. NEW YORK BAY

(FROM THE TELEGRAPH STATION)

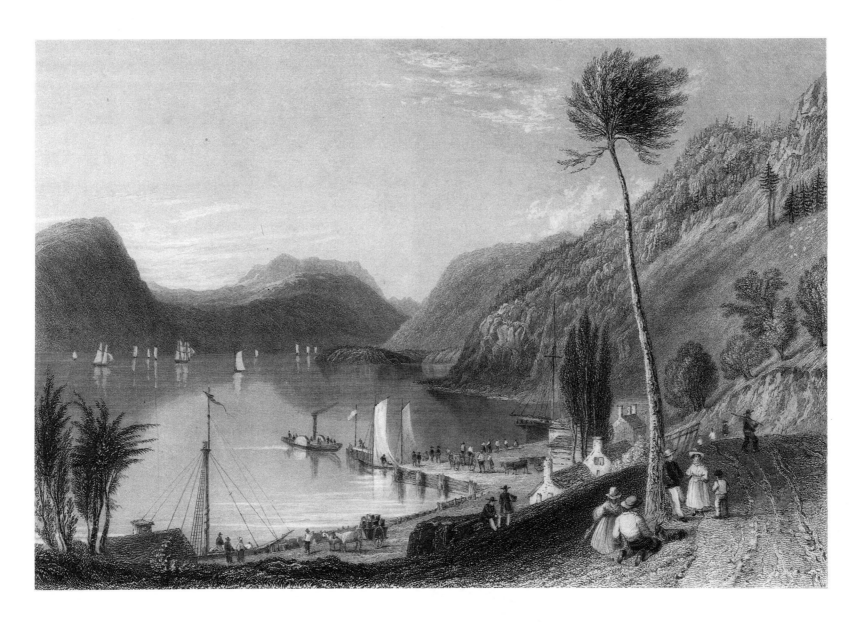

30. PEEKSKILL LANDING

(HUDSON RIVER)

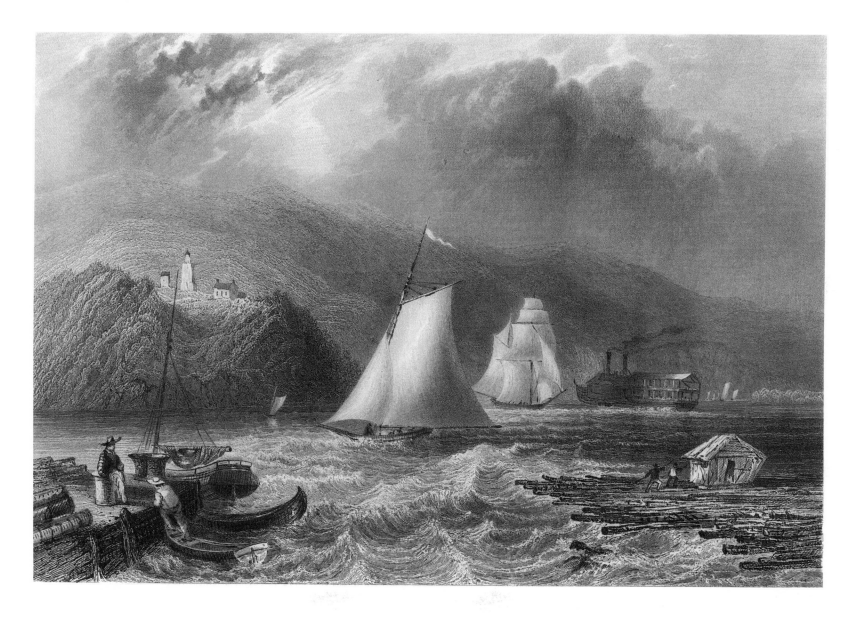

31. LIGHTHOUSE, NEAR CALDWELL LANDING

(HUDSON RIVER)

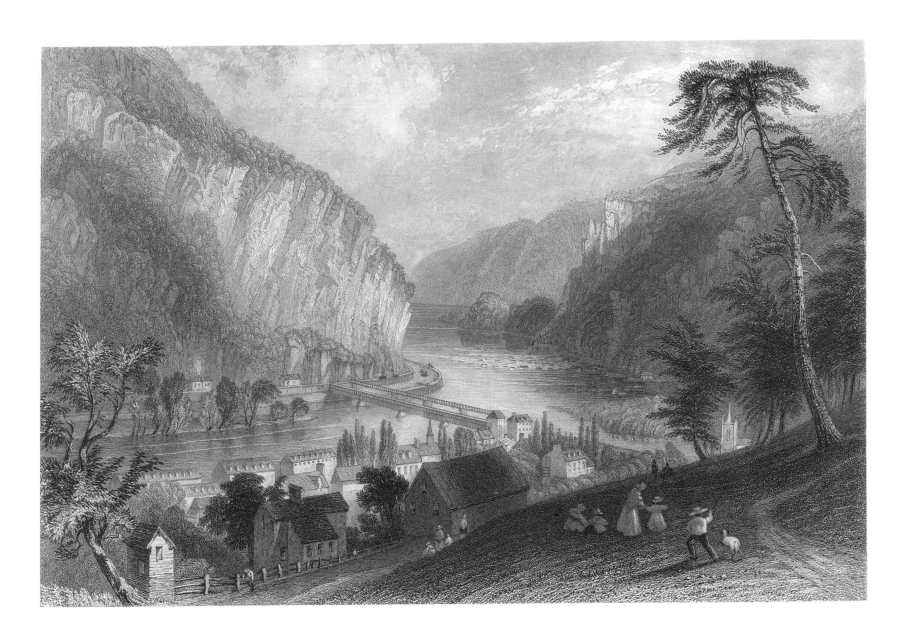

32. HARPERS FERRY

(FROM THE POTOMAC SIDE)

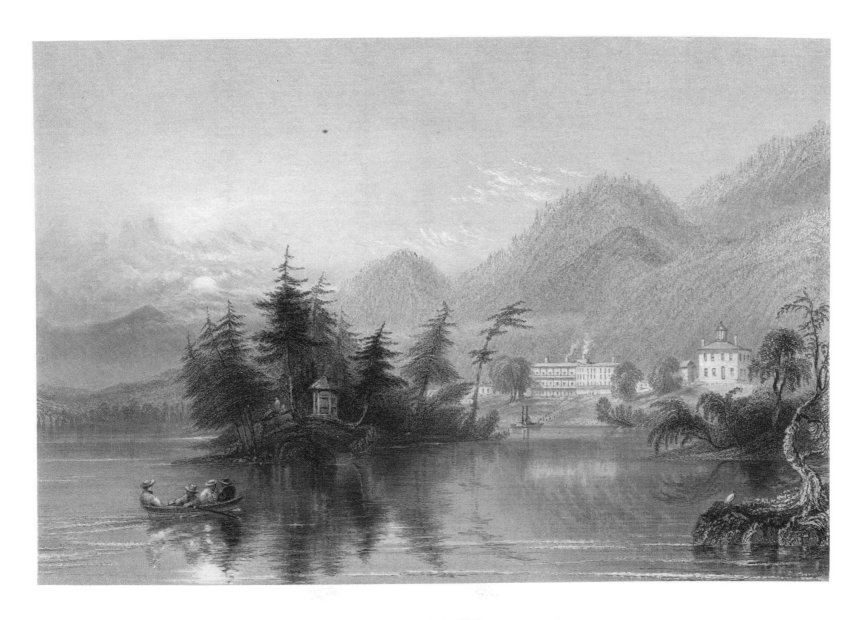

33. CALDWELL

(LAKE GEORGE)

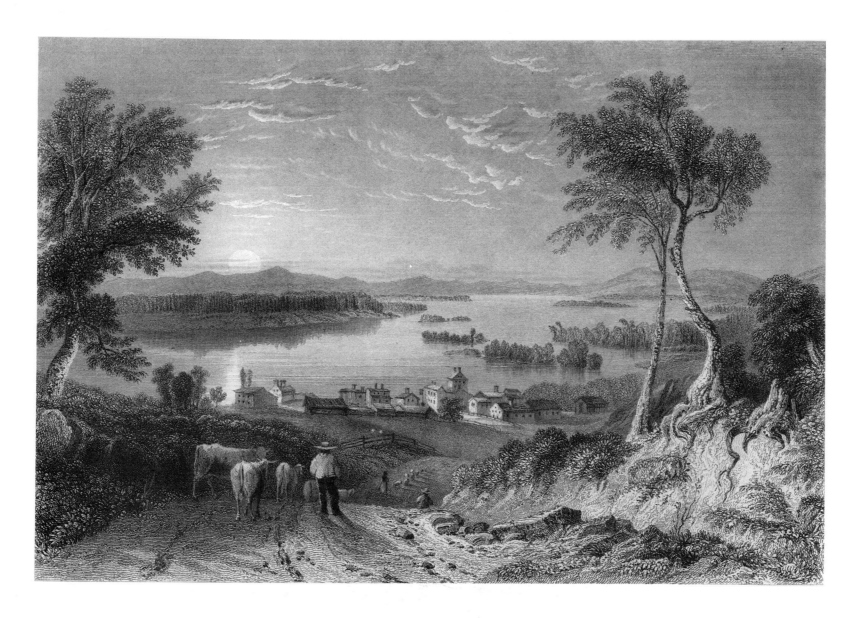

34. CENTRE HARBOUR

(LAKE WINNIPESAUKEE)

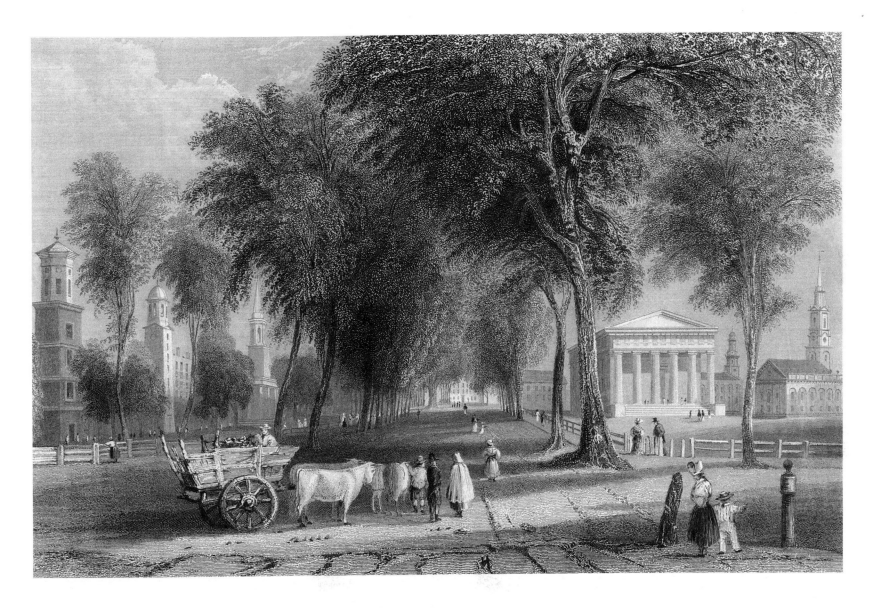

35. YALE COLLEGE

(NEW HAVEN)

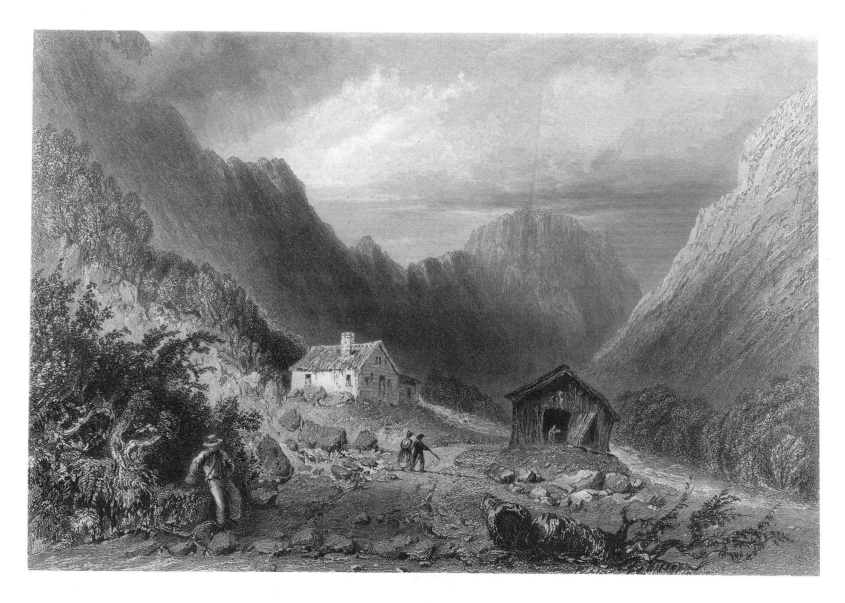

36. WILLEY HOUSE, WHITE MOUNTAINS

(NEW HAMPSHIRE)

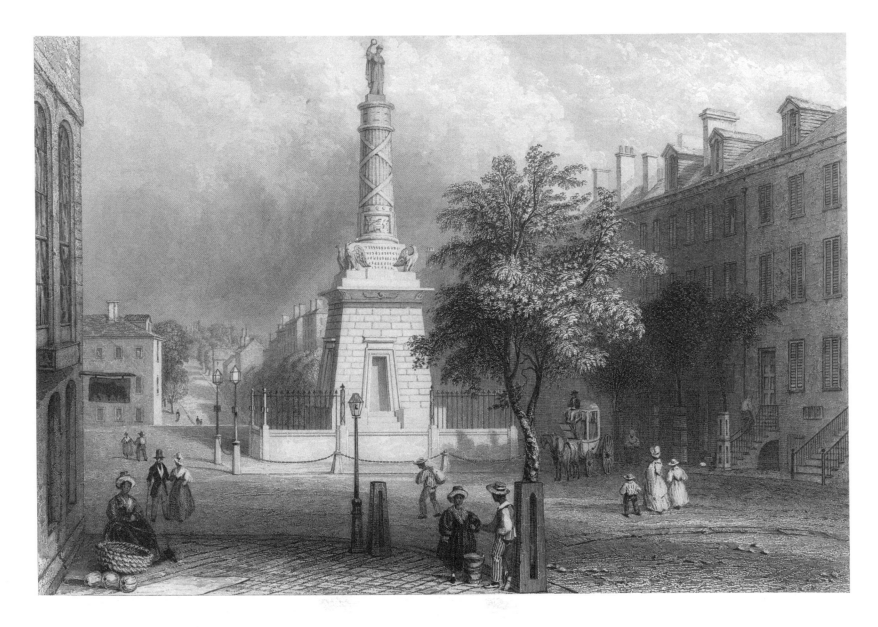

37. BATTLE MONUMENT, BALTIMORE

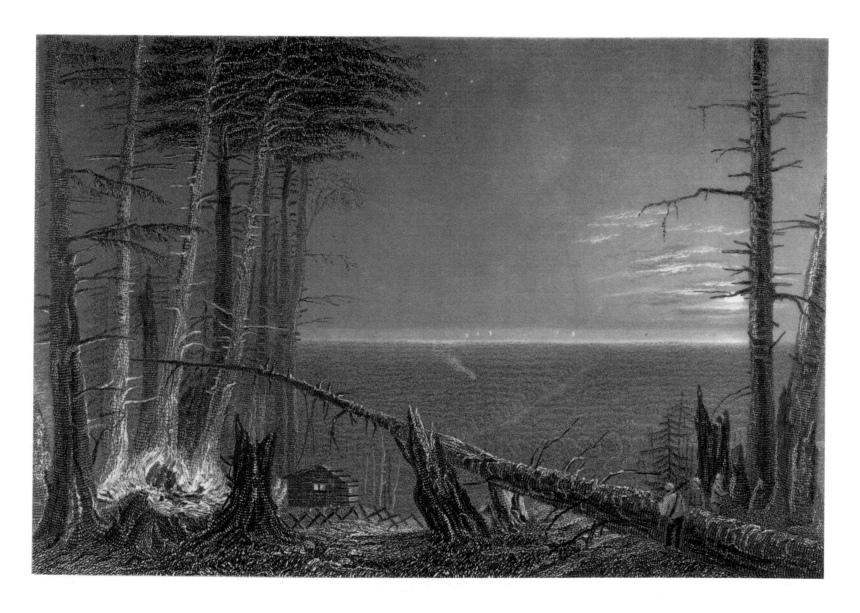

38. A FOREST SCENE ON LAKE ONTARIO

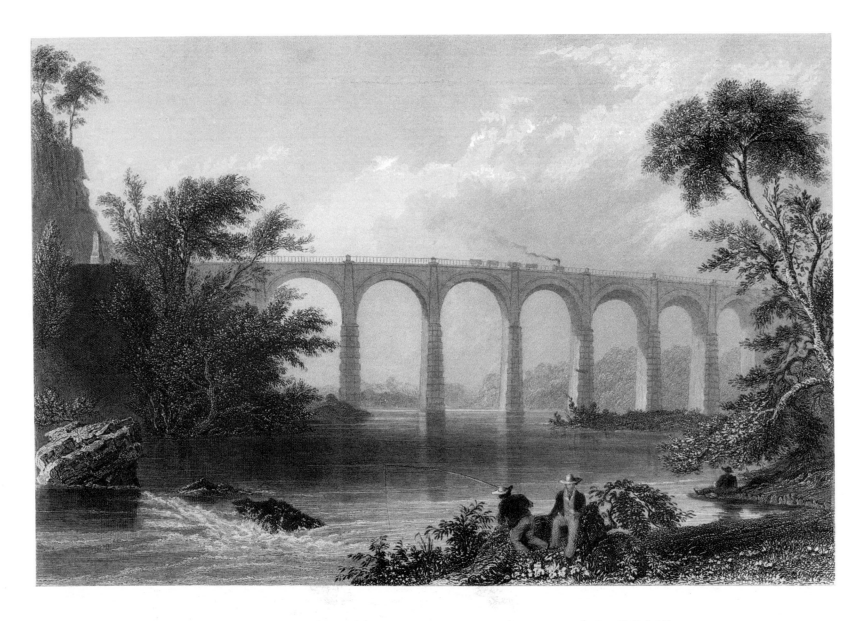

39. VIADUCT ON THE BALTIMORE AND WASHINGTON RAILROAD

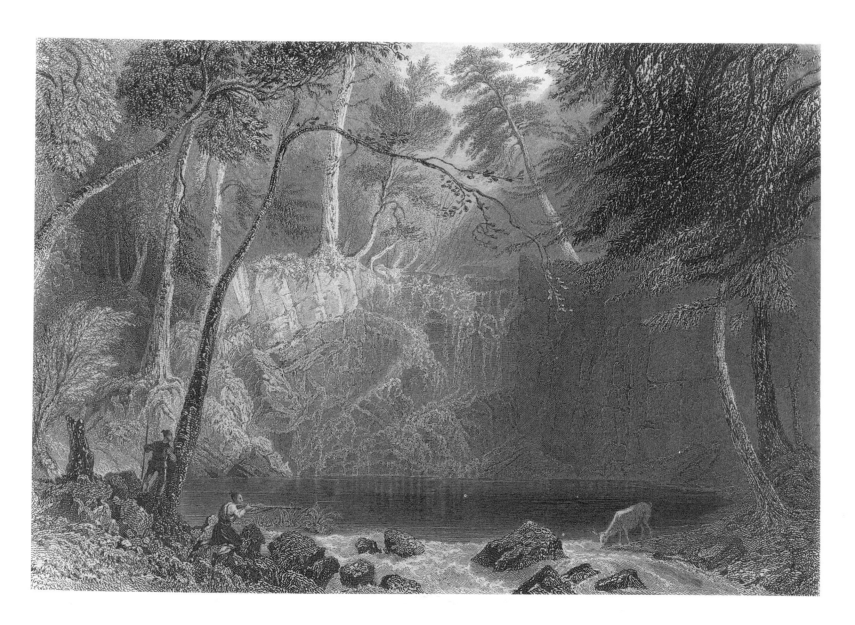

40. THE INDIAN FALLS NEAR COLDSPRING

(OPPOSITE WEST POINT)

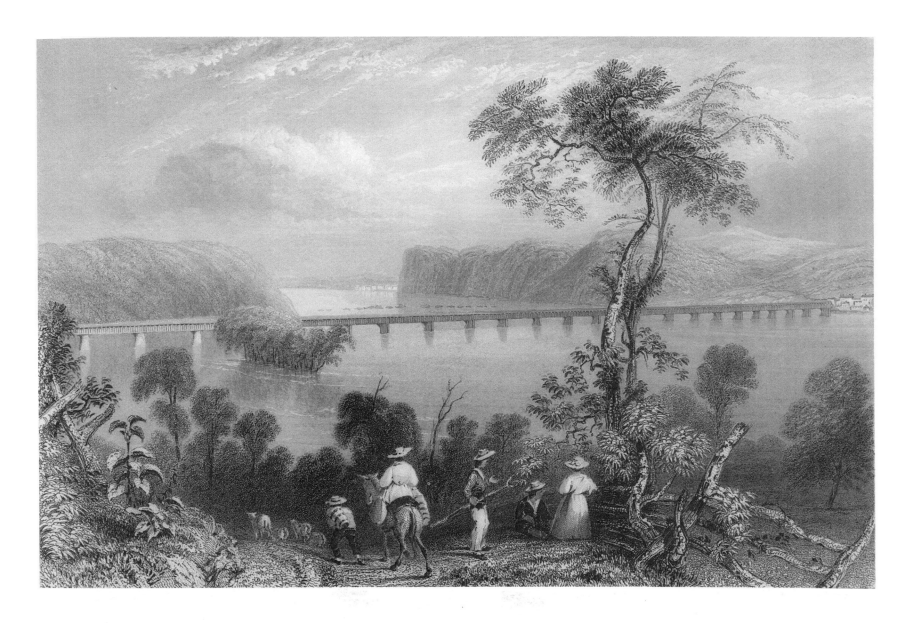

41. COLUMBIA BRIDGE

(ON THE SUSQUEHANNA)

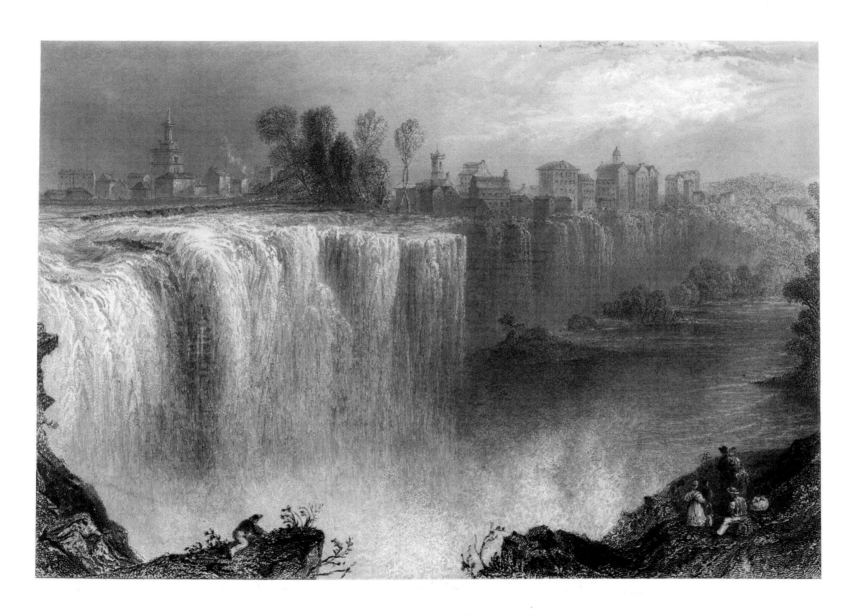

42. THE GENESEE FALLS, ROCHESTER

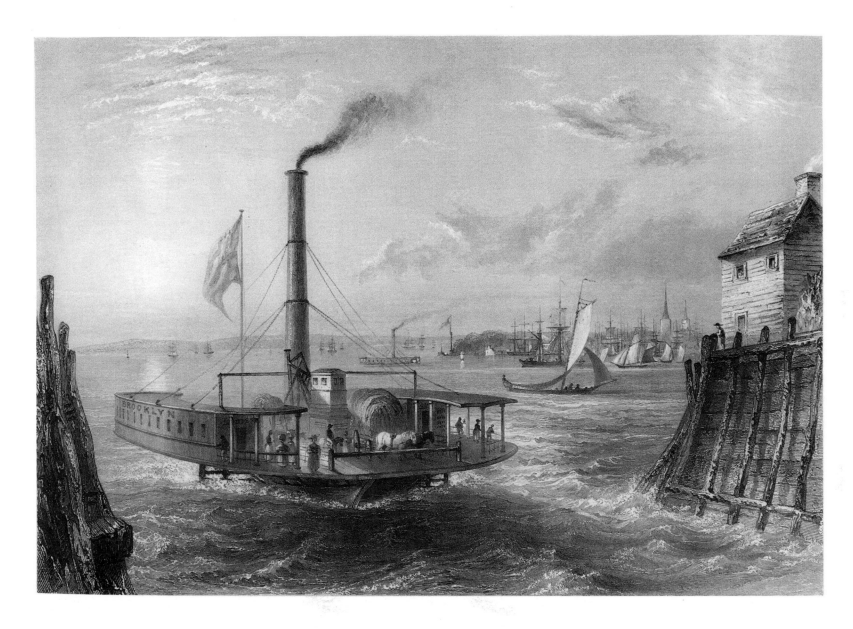

43. THE FERRY AT BROOKLYN, NEW YORK

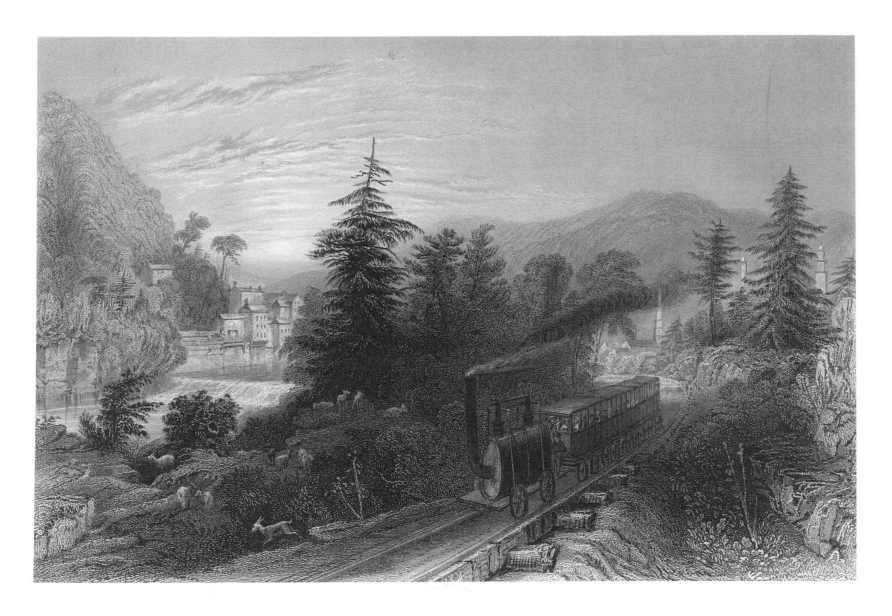

44. RAILROAD SCENE, LITTLE FALLS

(VALLEY OF THE MOHAWK)

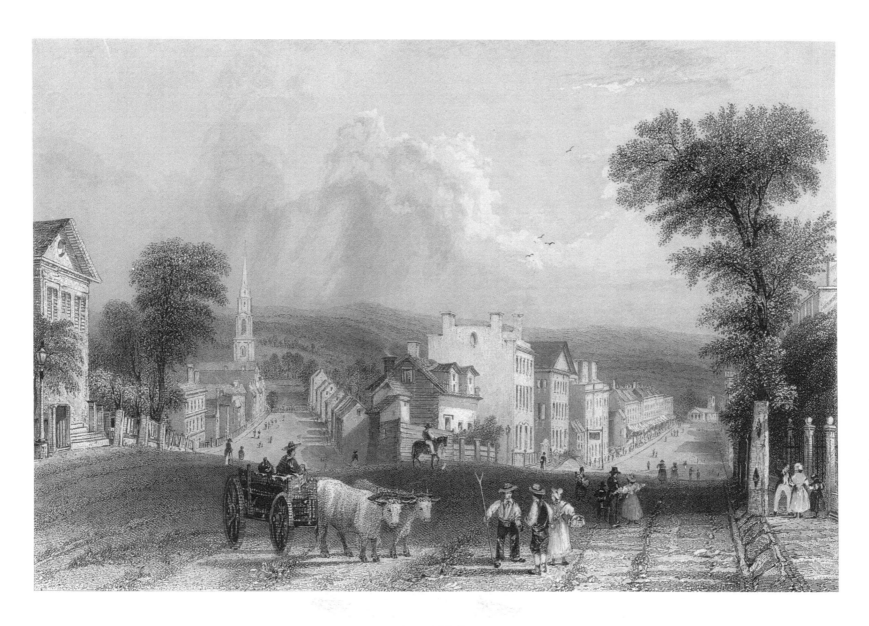

45. UTICA

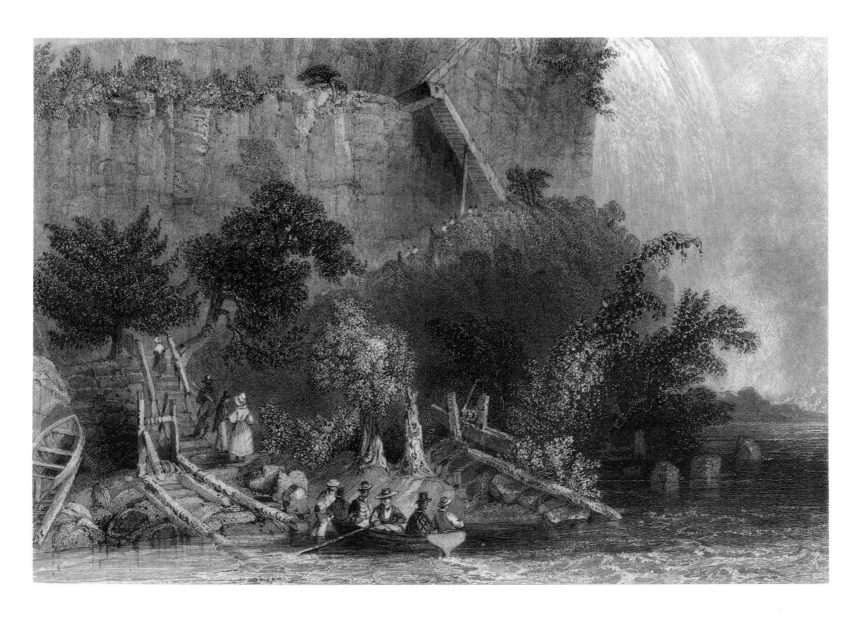

46. THE LANDING, ON THE AMERICAN SIDE, FALLS OF NIAGARA

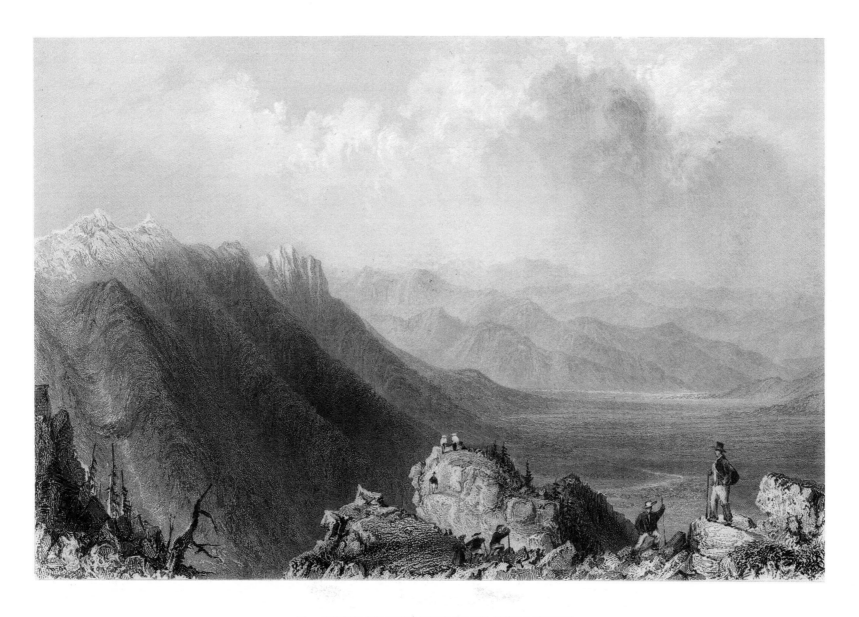

47. VIEW FROM MOUNT WASHINGTON

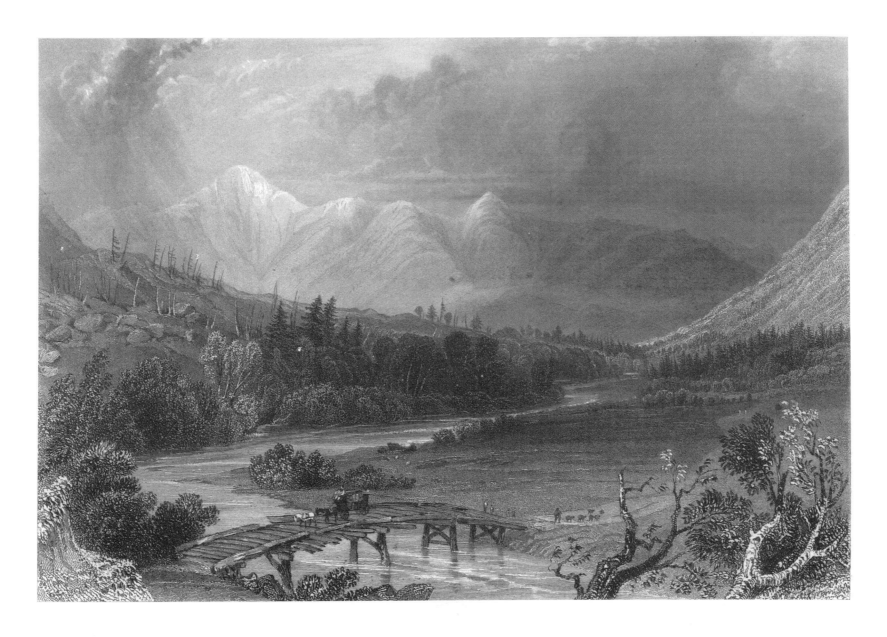

48. MOUNT WASHINGTON, AND THE WHITE HILLS

(FROM NEAR CRAWFORD'S)

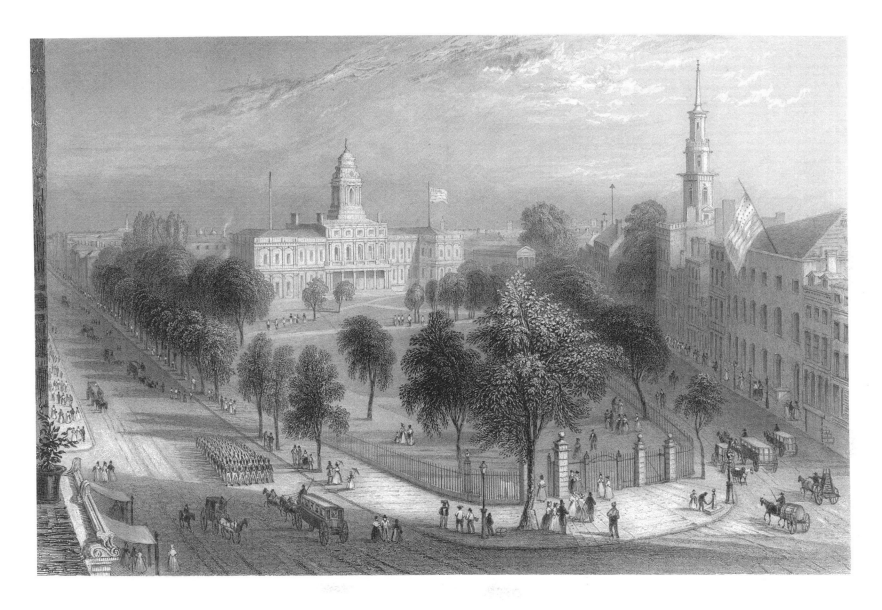

49. THE PARK AND CITY HALL, NEW YORK

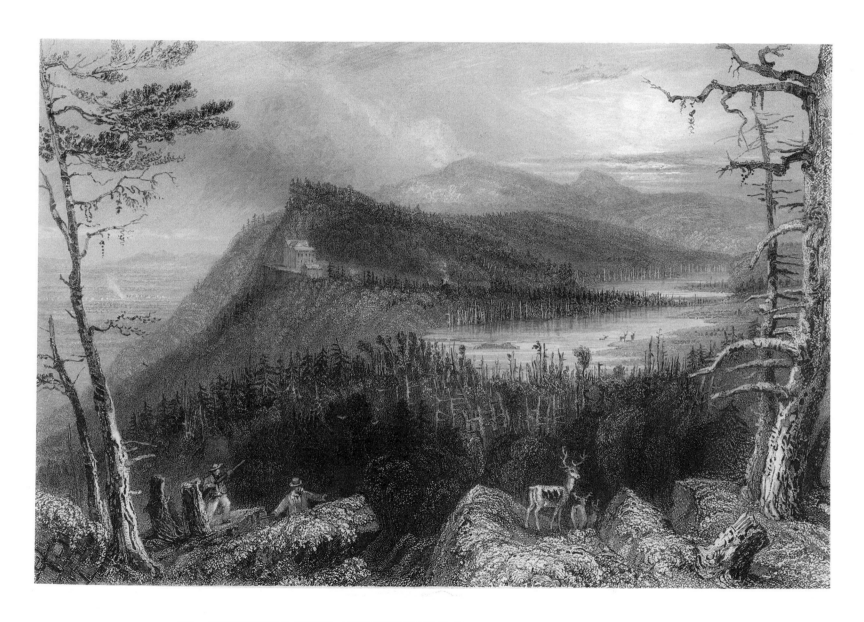

50. THE TWO LAKES, AND THE MOUNTAIN HOUSE ON THE CATSKILLS

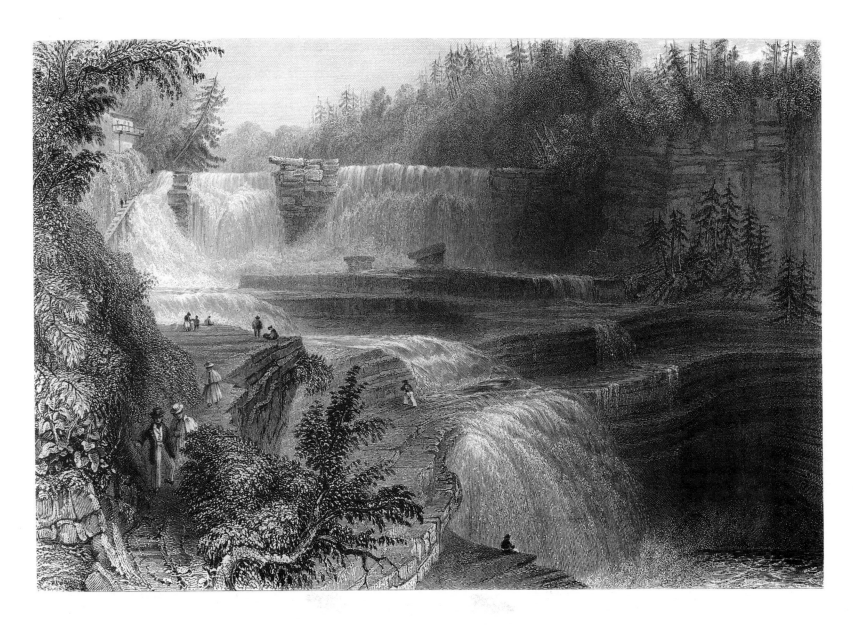

51. TRENTON HIGH FALLS

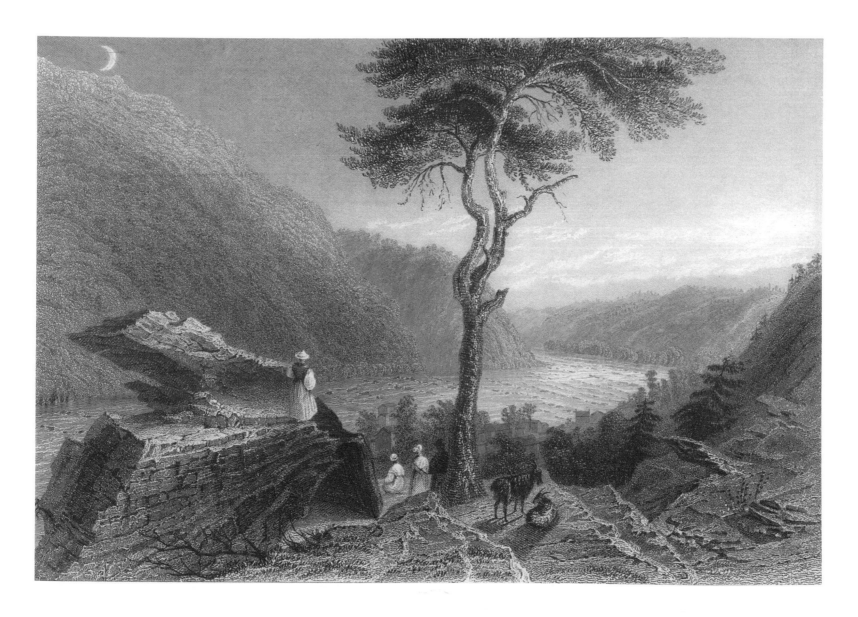

52. THE VALLEY OF THE SHENANDOAH, FROM JEFFERSON'S ROCK

(HARPERS FERRY)

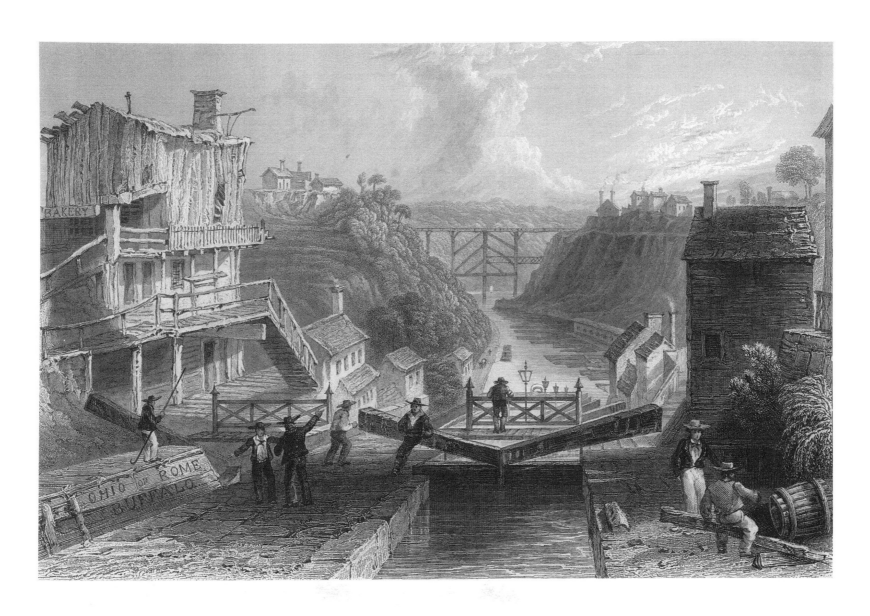

53. LOCKPORT, ERIE CANAL

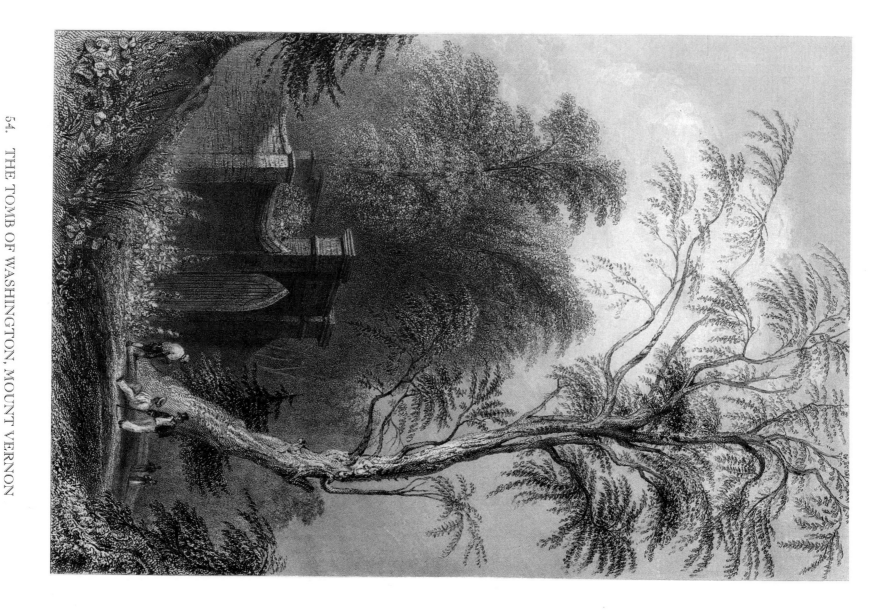

54. THE TOMB OF WASHINGTON, MOUNT VERNON

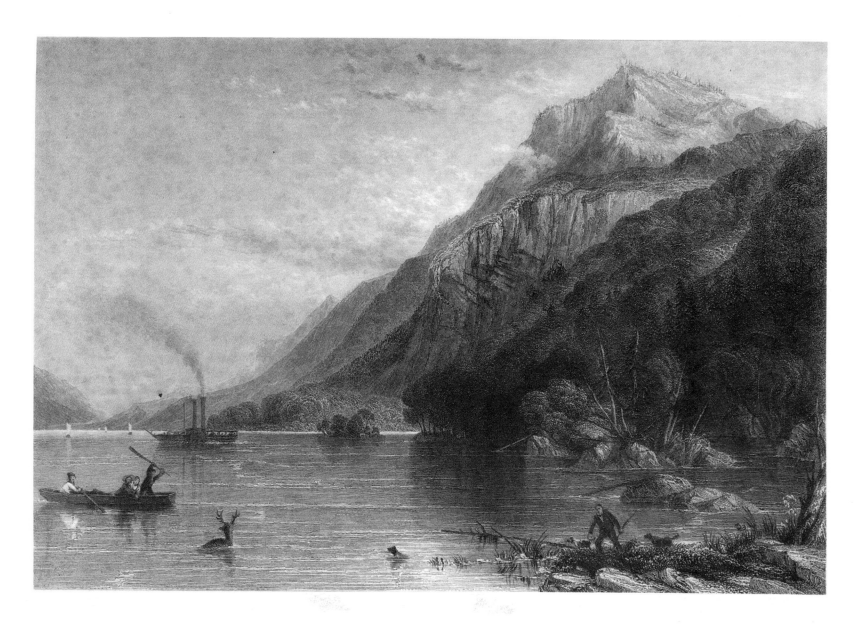

55. BLACK MOUNTAIN

(LAKE GEORGE)

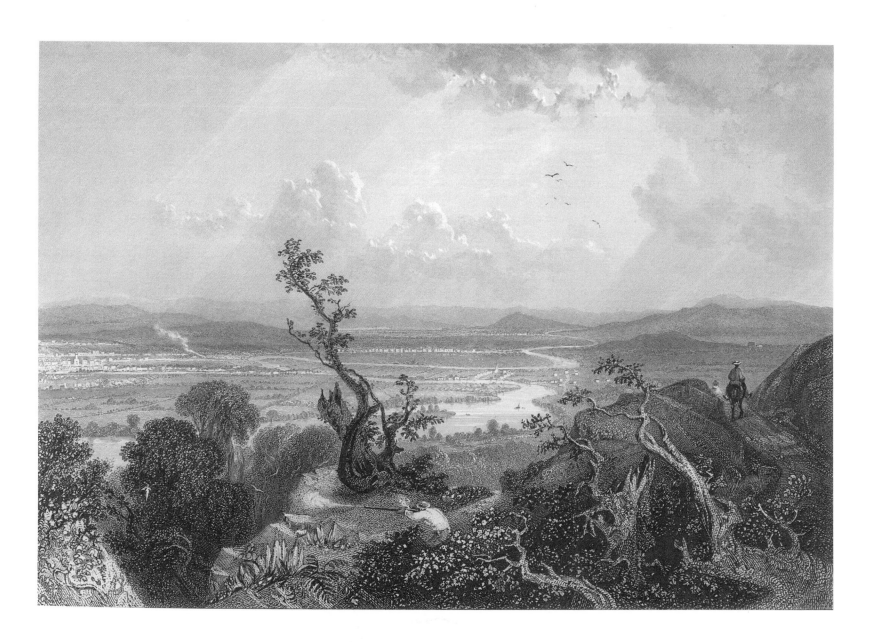

56. VALLEY OF THE CONNECTICUT

(FROM MOUNT HOLYOKE)

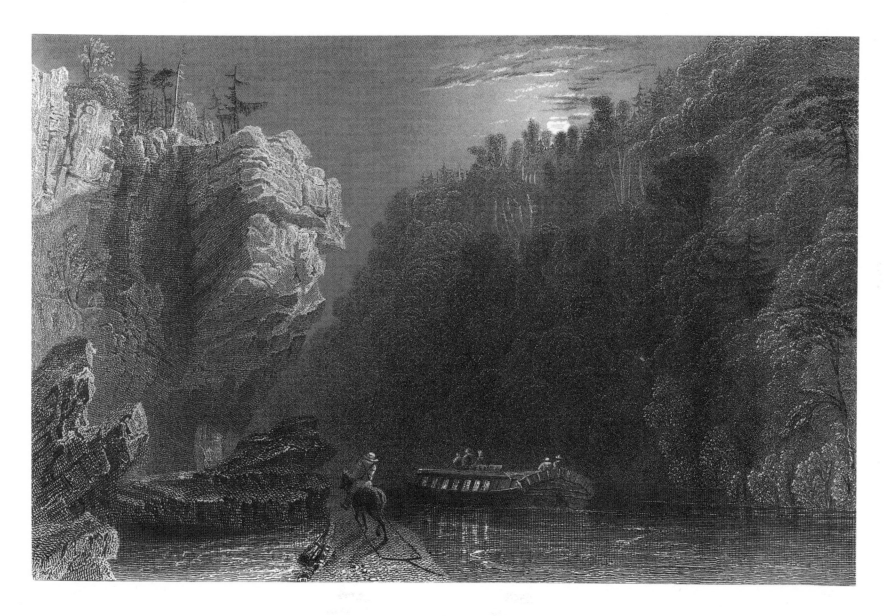

57. VIEW ON THE ERIE CANAL, NEAR LITTLE FALLS

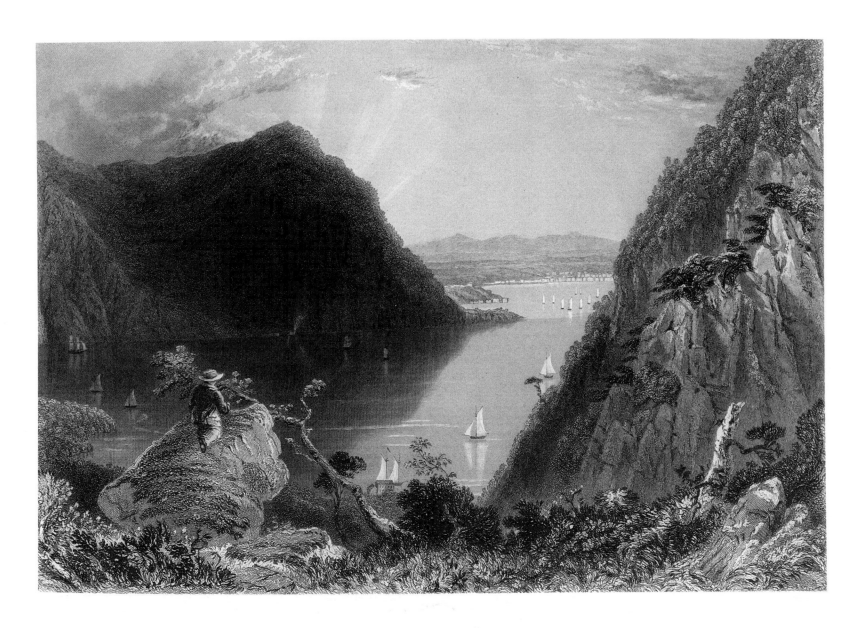

58. HUDSON HIGHLANDS

(FROM BULL HILL)

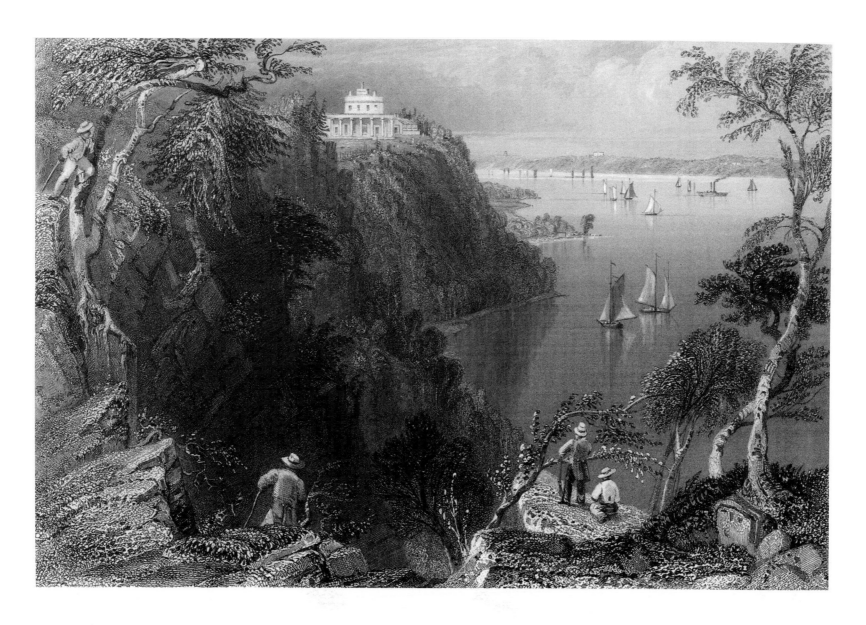

59. VILLA ON THE HUDSON, NEAR WEEHAWKEN

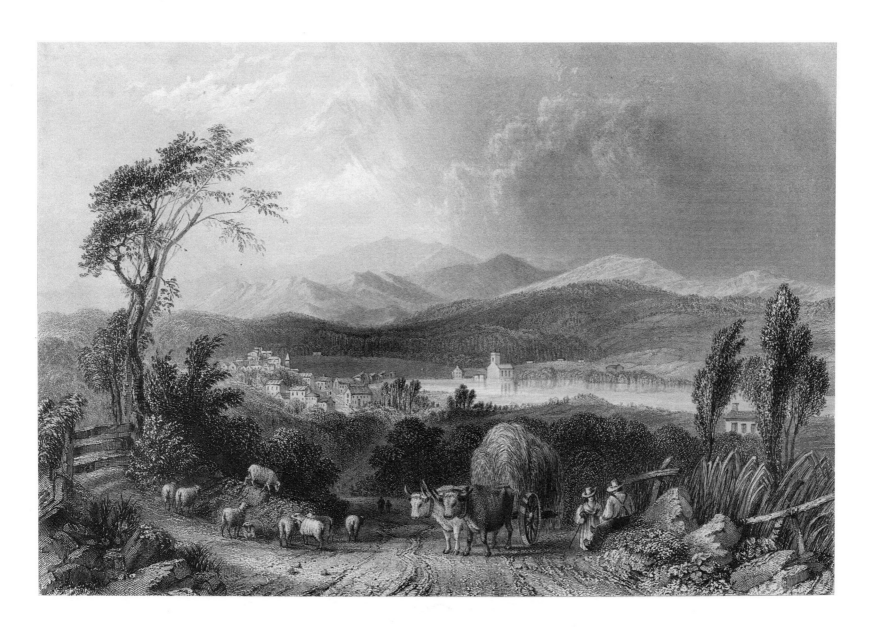

60. VIEW OF MEREDITH

(NEW HAMPSHIRE)

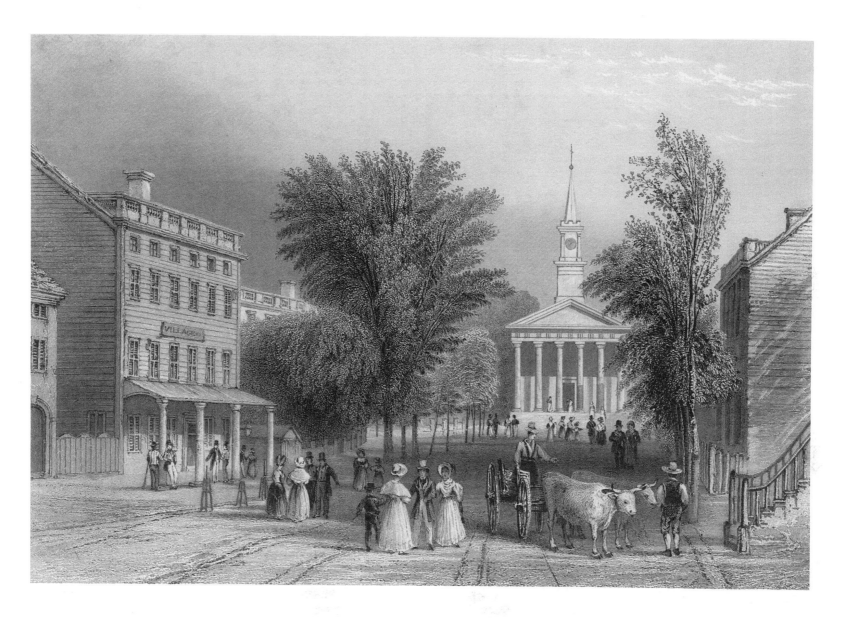

61. BALLSTON SPRINGS, NEW YORK

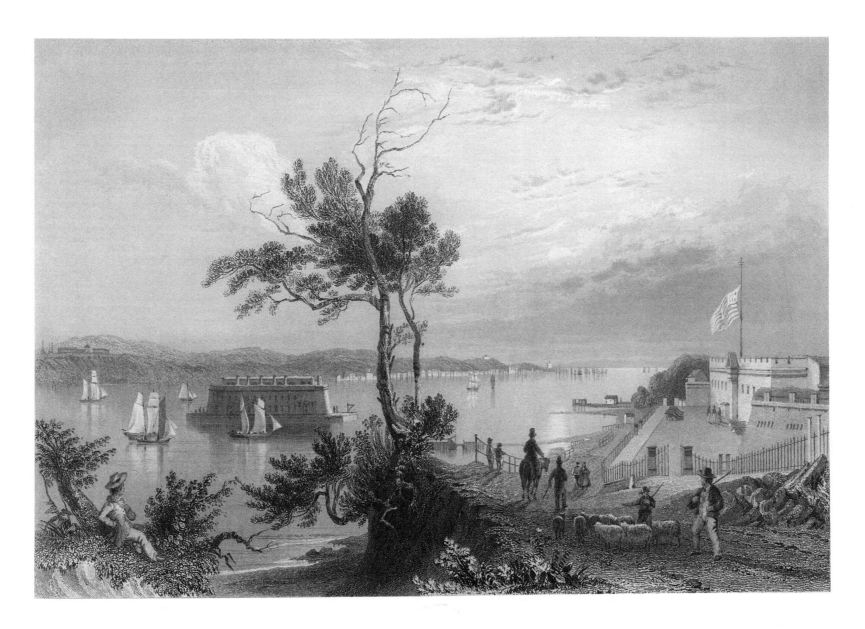

62. THE NARROWS

(FROM FORT HAMILTON)

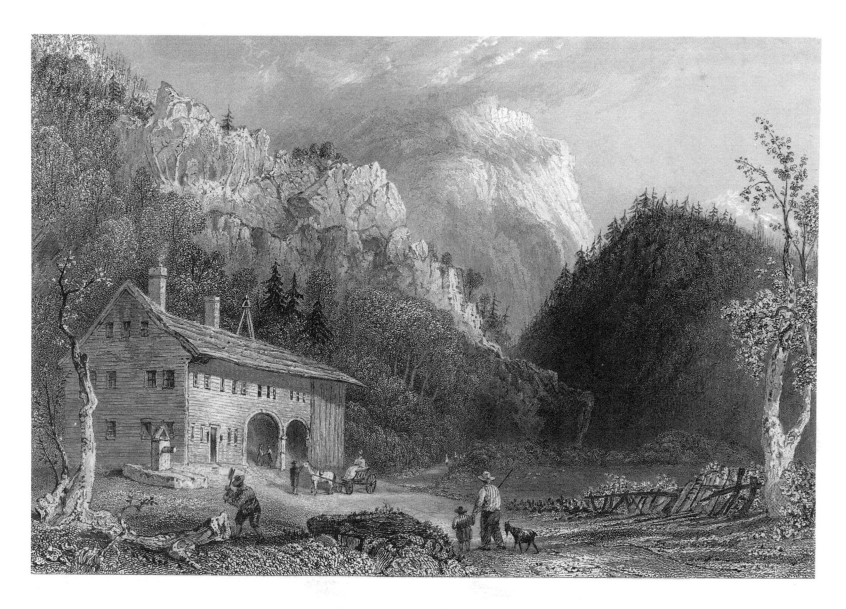

63. THE NOTCH HOUSE, WHITE MOUNTAINS

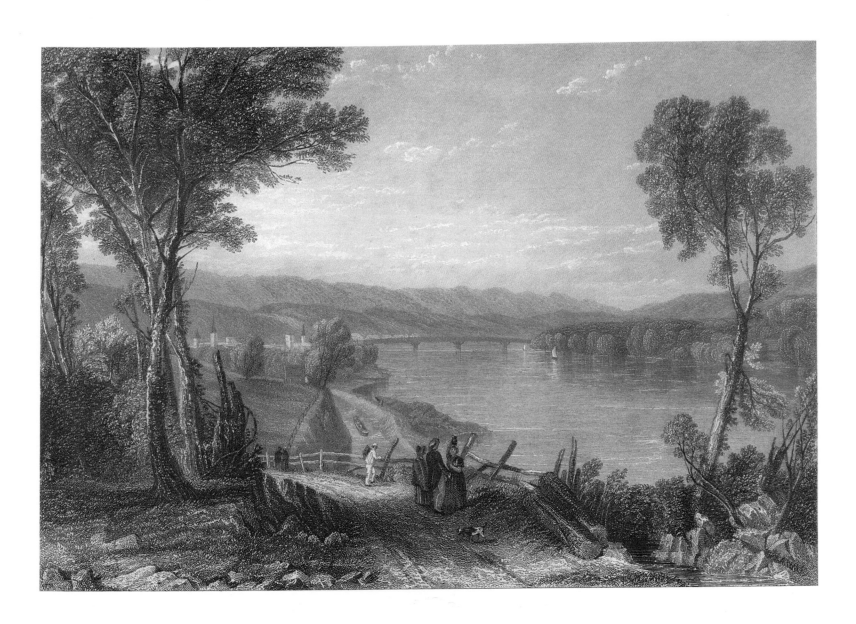

64. WILKESBARRE

(VALE OF WYOMING)

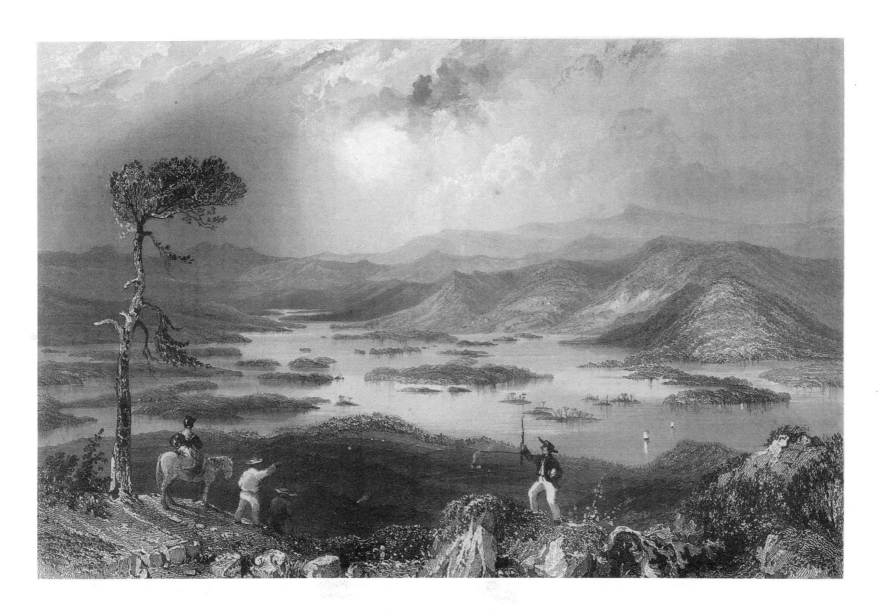

65. SQUAM LAKE, NEW HAMPSHIRE

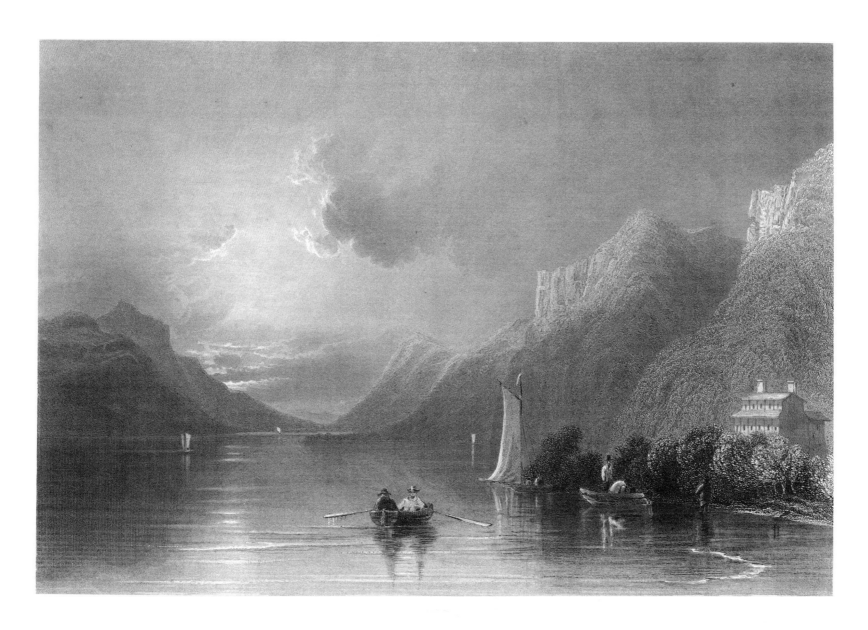

66. SABBATH-DAY POINT

(LAKE GEORGE)

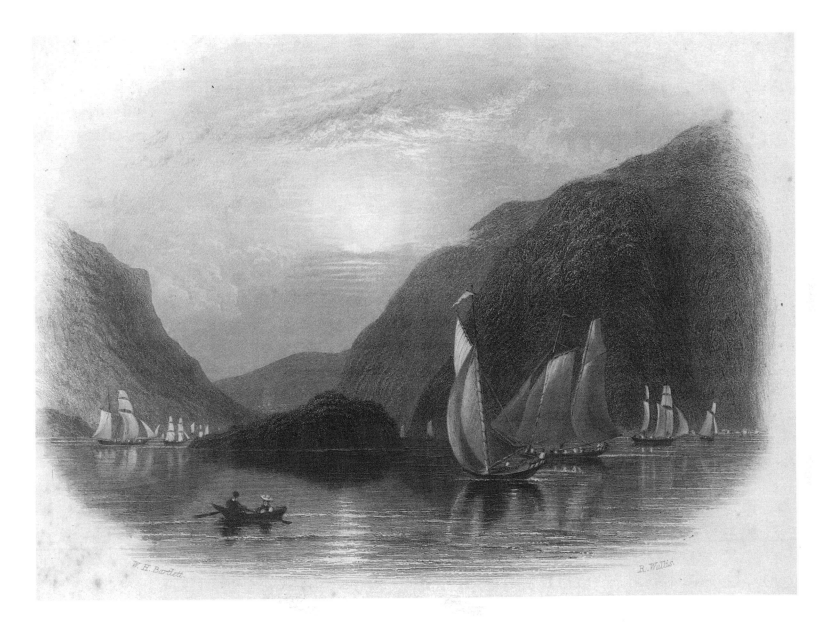

W. H. Bartlett. R. Wallis.

67. ENTRANCE TO THE HUDSON HIGHLANDS, NEAR NEWBURGH

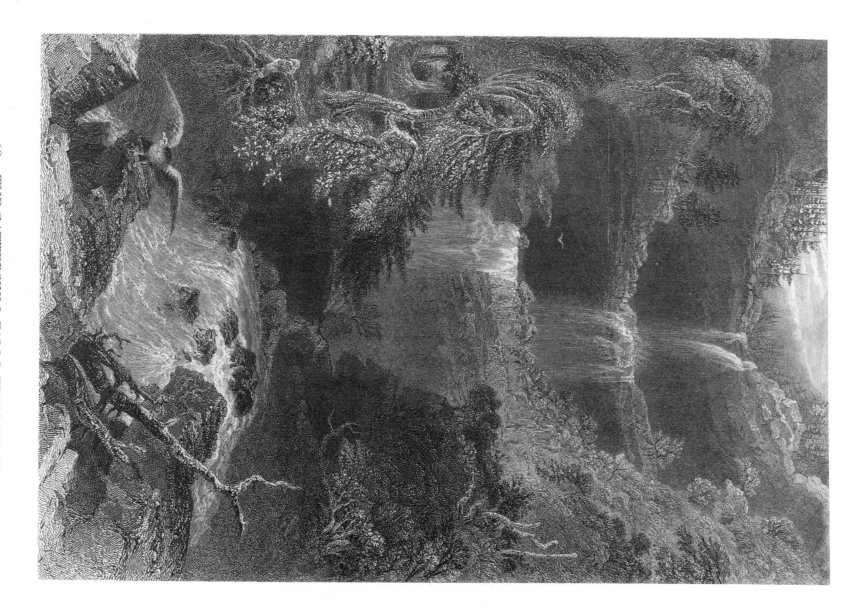

68. THE CATTERSKILL FALLS, FROM BELOW

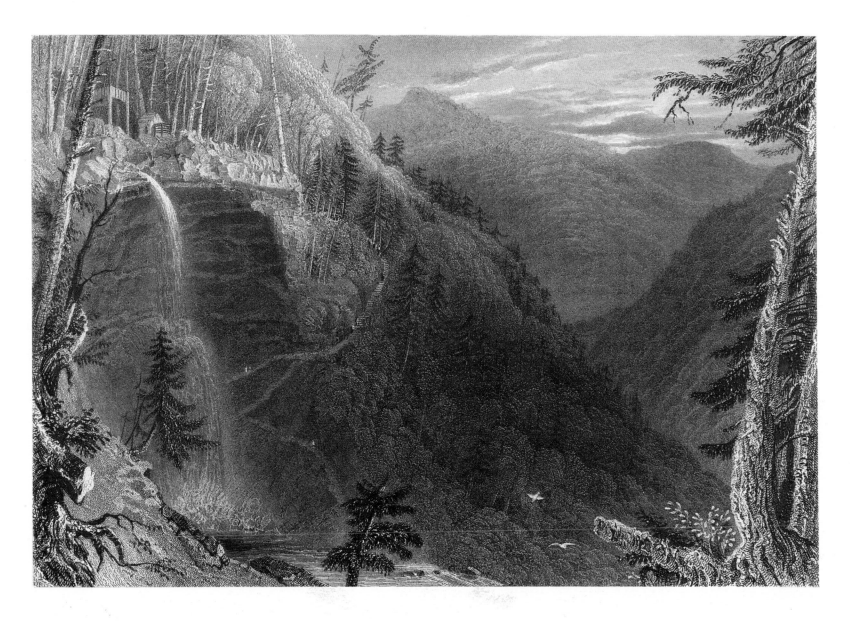

69. THE CATTERSKILL FALLS, FROM ABOVE THE RAVINE

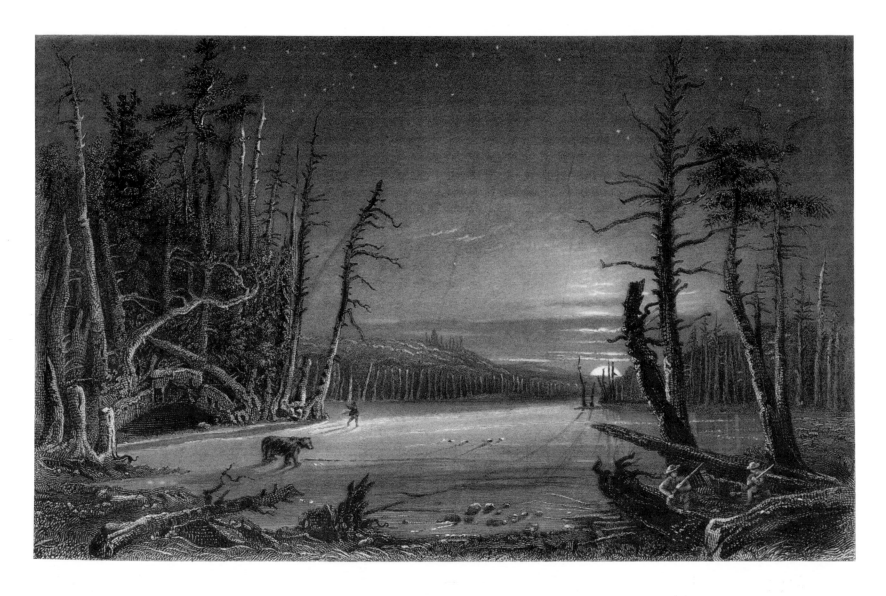

70. WINTER SCENE ON THE CATTERSKILLS

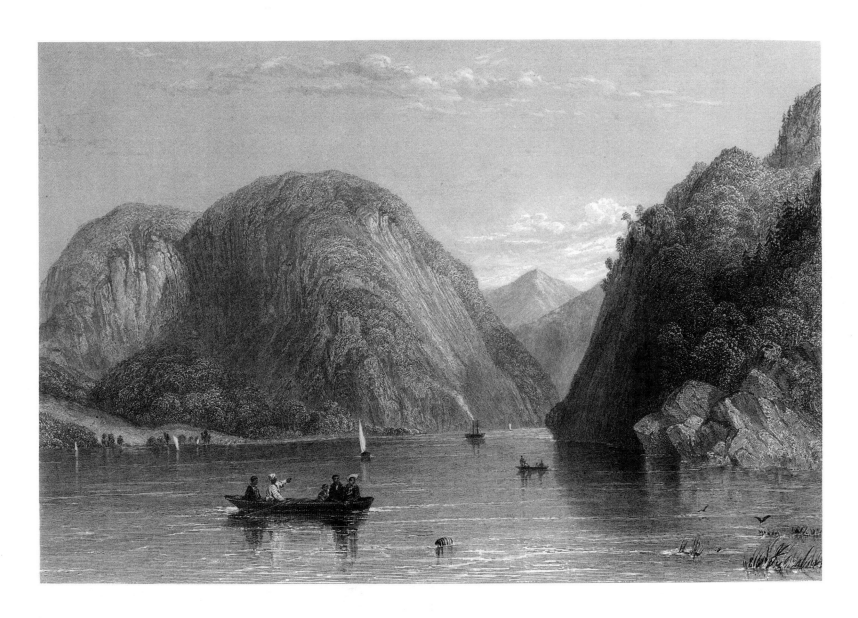

71. ROGERS' SLIDE, LAKE GEORGE

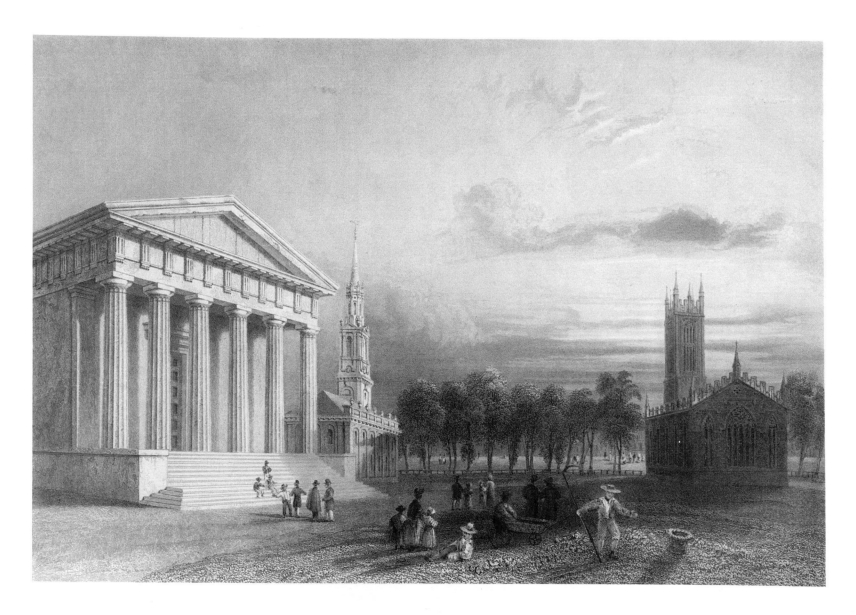

72. THE GOTHIC CHURCH

(NEW HAVEN)

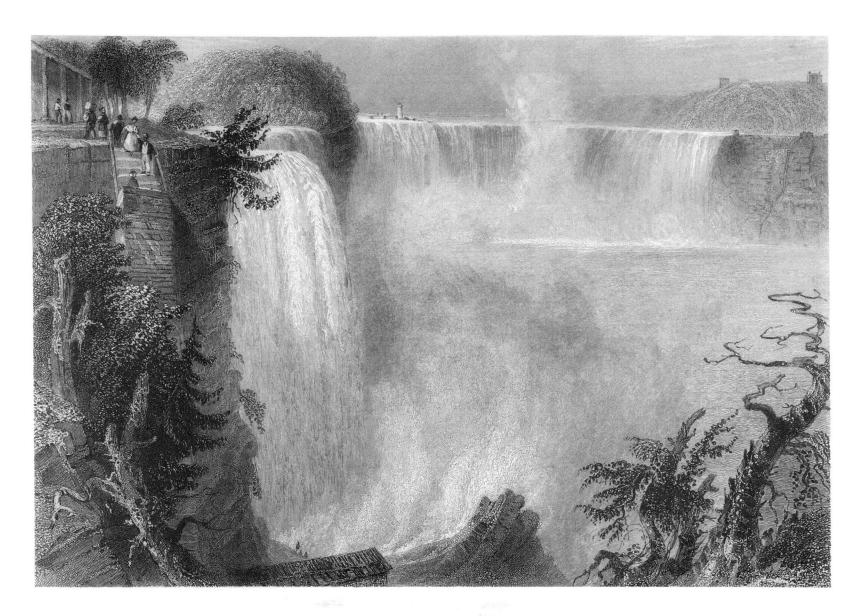

73. NIAGARA FALLS

(FROM THE TOP OF THE LADDER, ON THE AMERICAN SIDE)

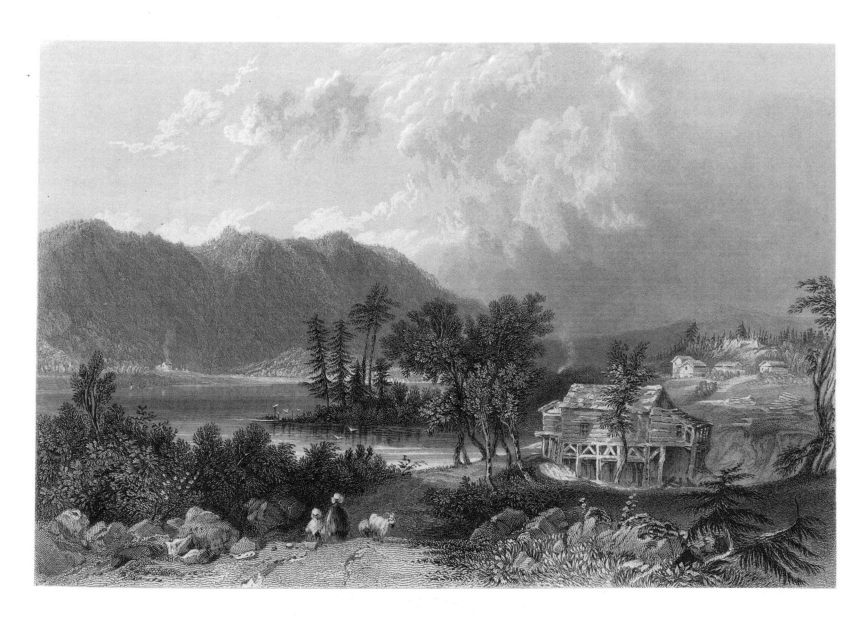

74. SAW-MILL AT CENTRE HARBOUR

(LAKE WINNIPESAUKEE)

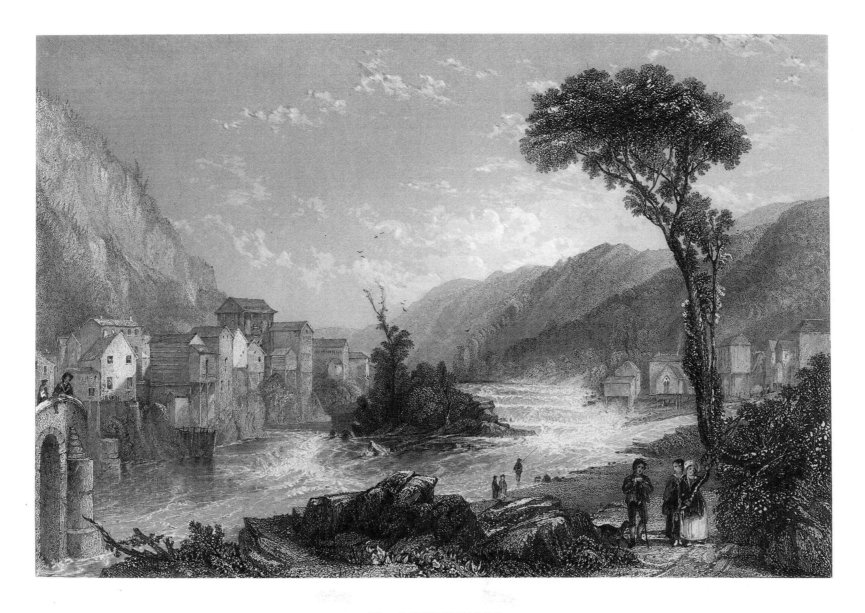

75. LITTLE FALLS

(ON THE MOHAWK)

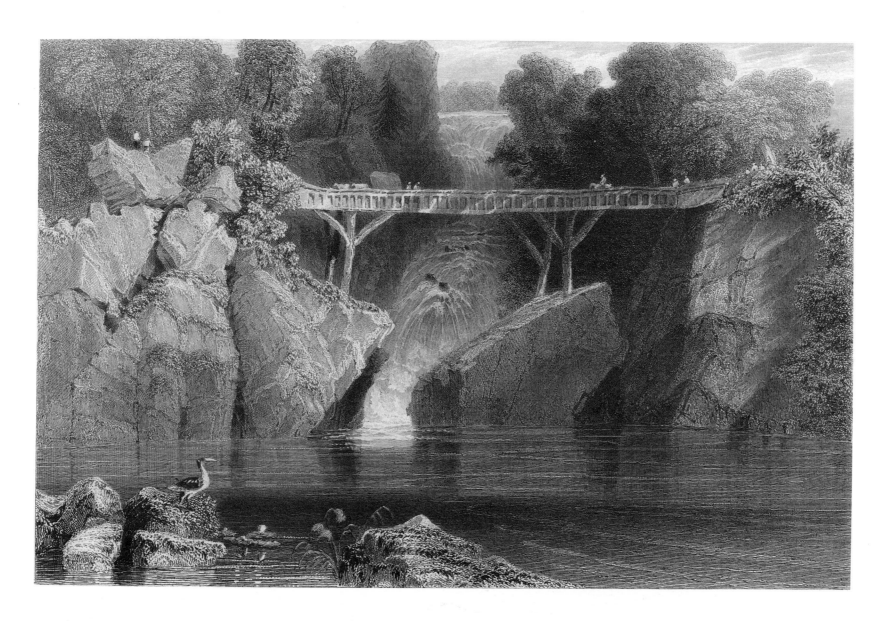

76. BRIDGE AT NORWICH

(CONNECTICUT)

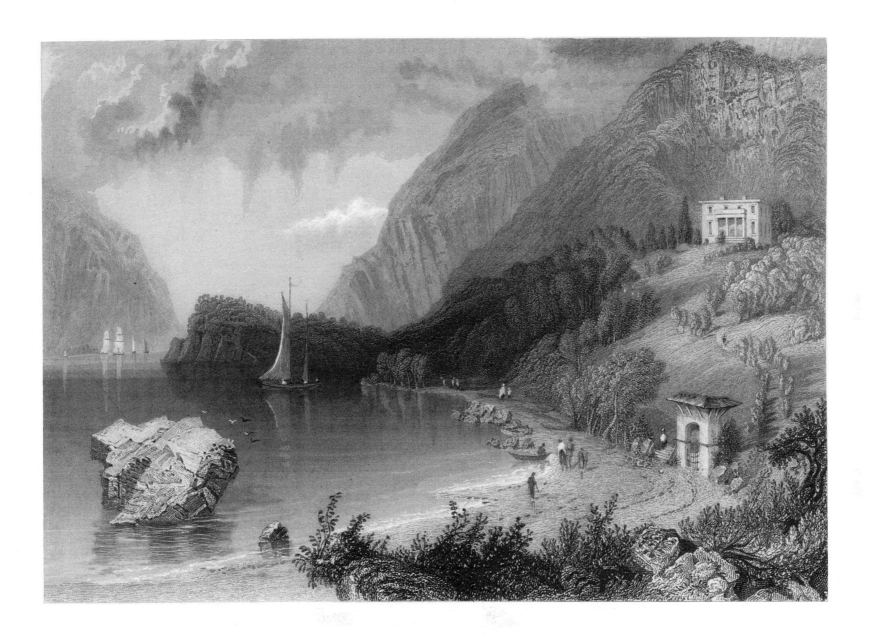

77. UNDERCLIFF, NEAR COLD SPRING

(THE SEAT OF GENERAL GEORGE P. MORRIS)

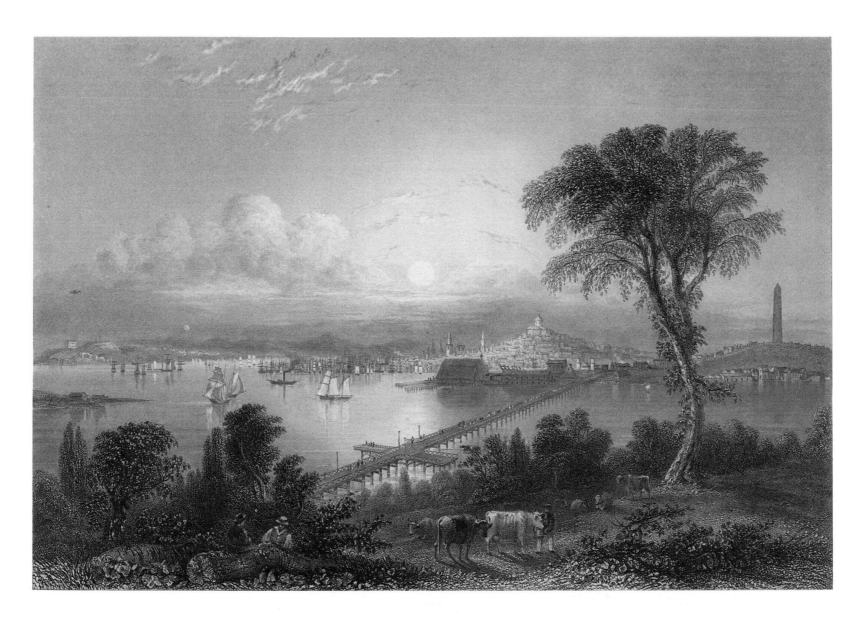

78. BOSTON, AND BUNKER HILL

(FROM THE EAST)

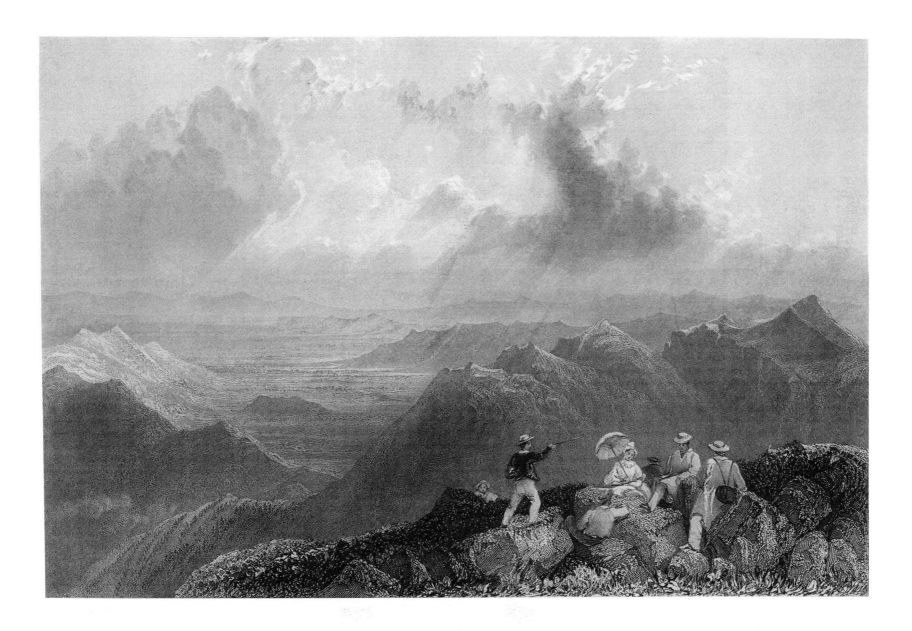

79. MOUNT JEFFERSON

(FROM MOUNT WASHINGTON)

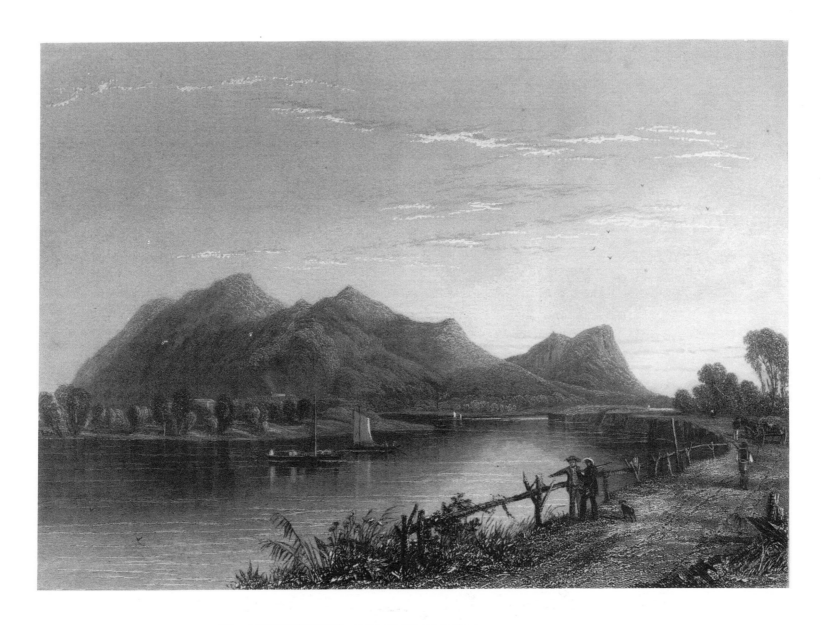

80. MOUNT TOM, AND THE CONNECTICUT RIVER

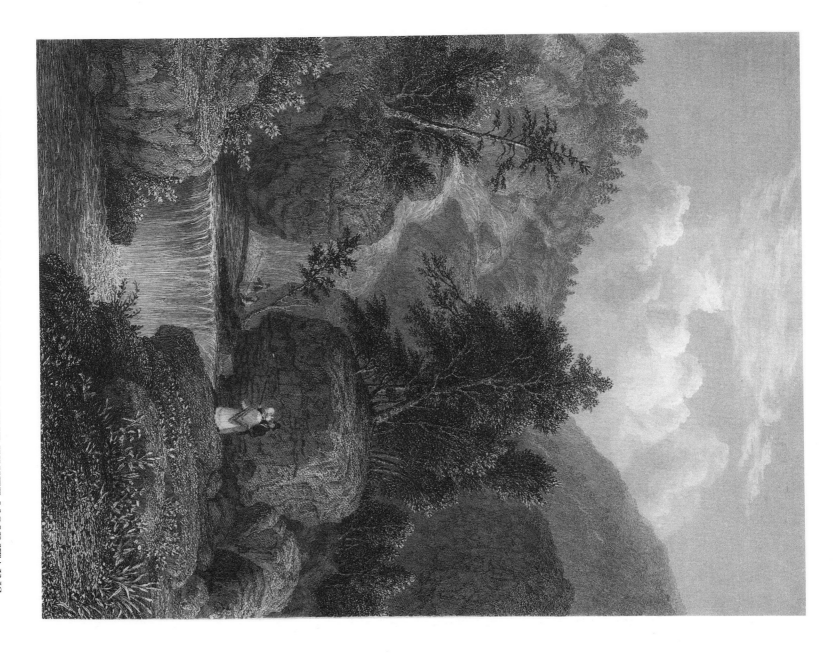

81. THE SILVER CASCADE, IN THE NOTCH OF THE WHITE MOUNTAINS

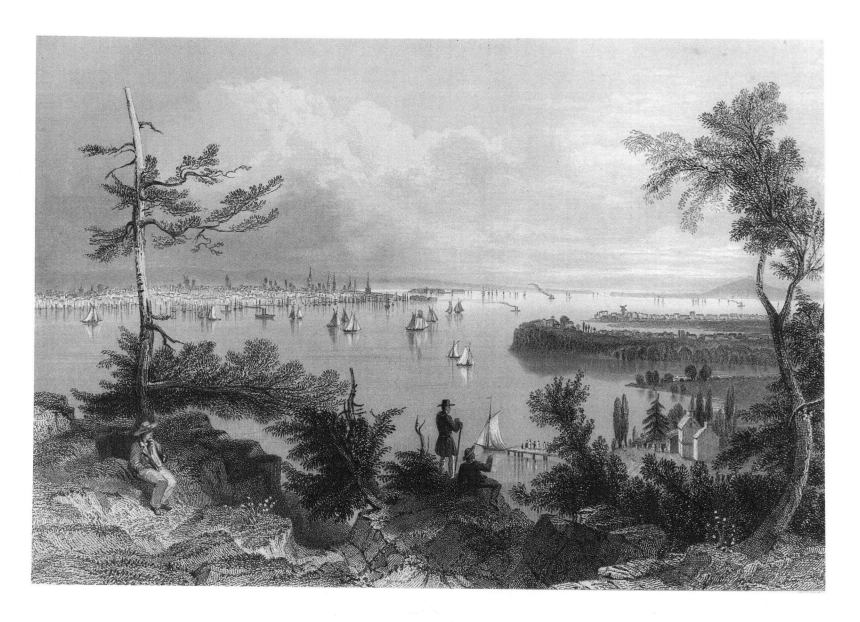

82. VIEW OF NEW YORK, FROM WEEHAWKEN

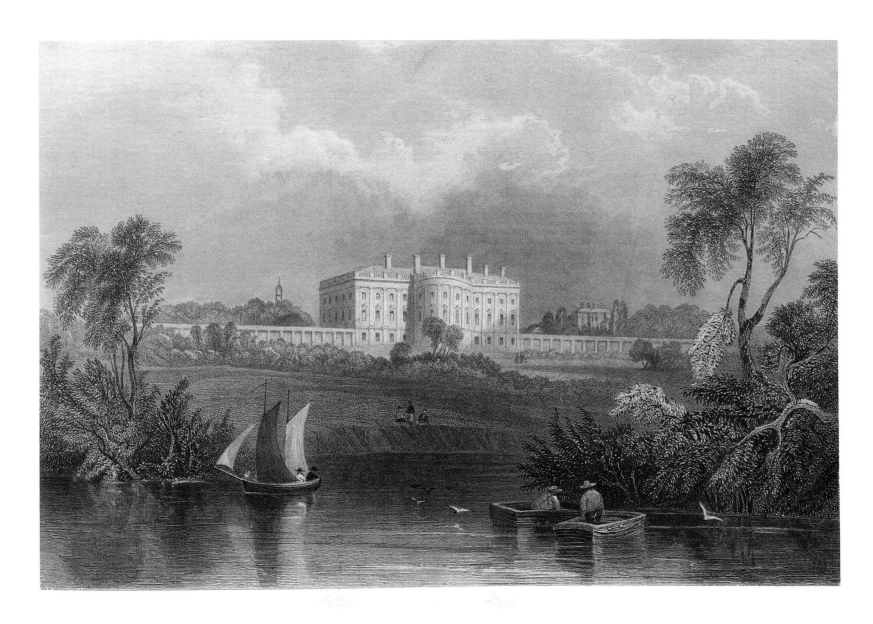

83. THE PRESIDENT'S HOUSE, FROM THE RIVER

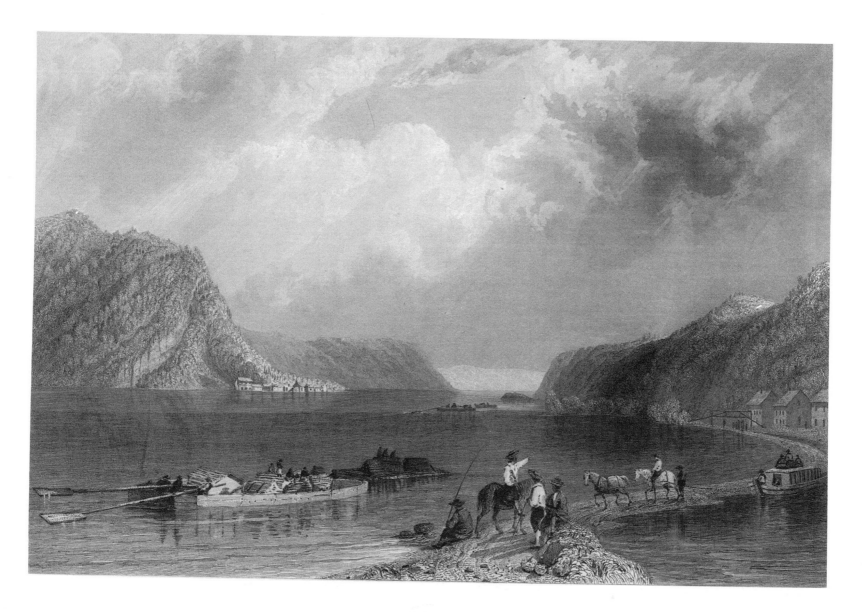

84. VIEW ON THE SUSQUEHANNA, AT LIVERPOOL

(PENNSYLVANIA)

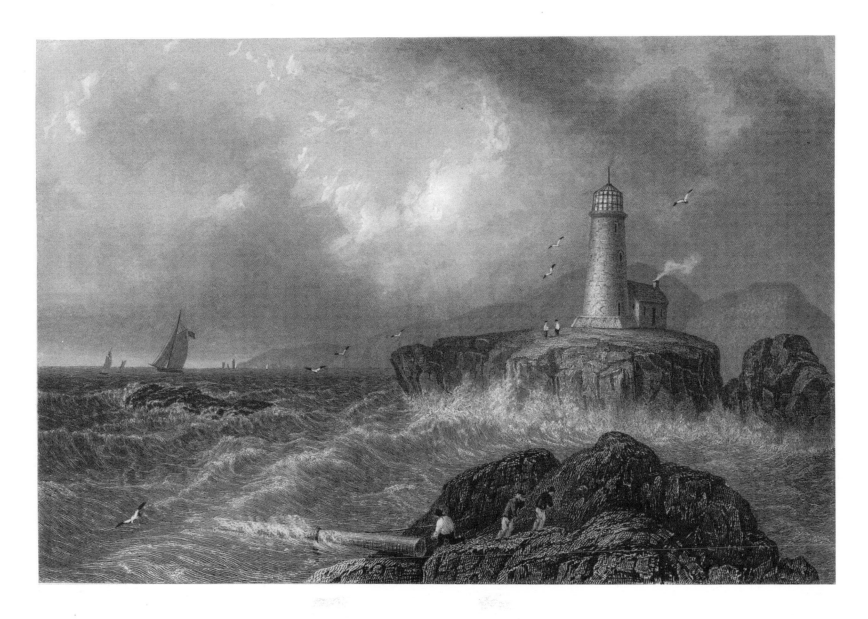

85. DESERT ROCK LIGHTHOUSE, MAINE

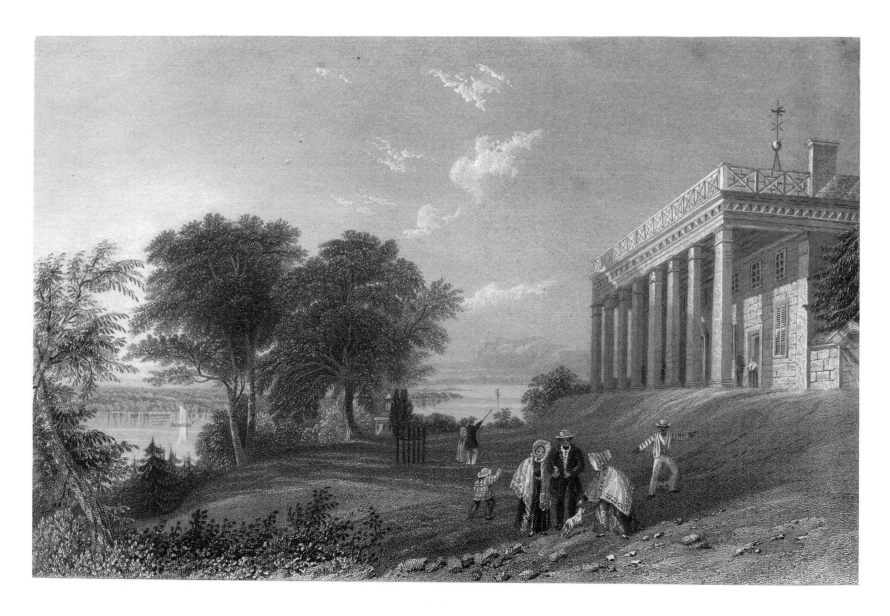

86. WASHINGTON'S HOUSE, MOUNT VERNON

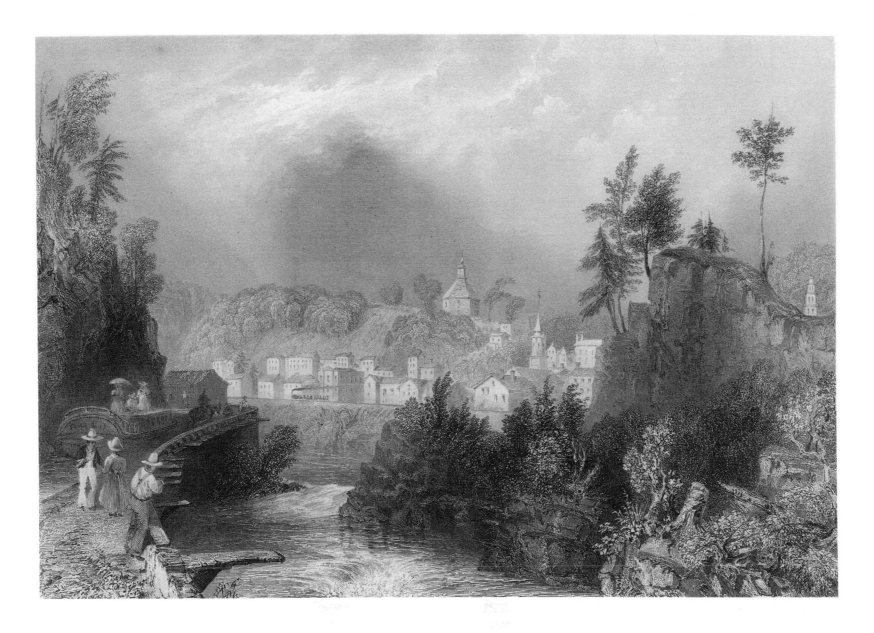

87. VILLAGE OF LITTLE FALLS

(MOHAWK RIVER)

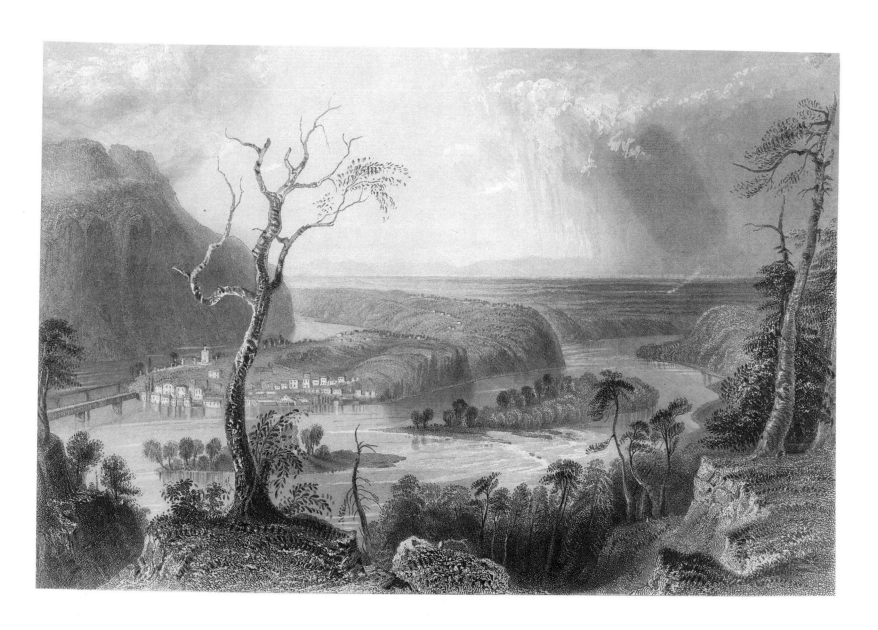

88. HARPERS FERRY

(FROM THE BLUE RIDGE)

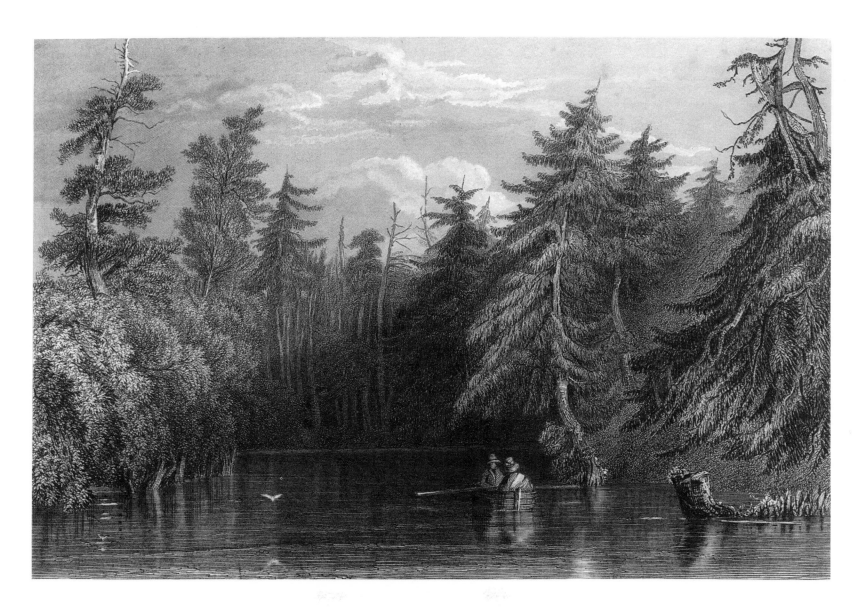

89. BARHYDT'S LAKE

(NEAR SARATOGA)

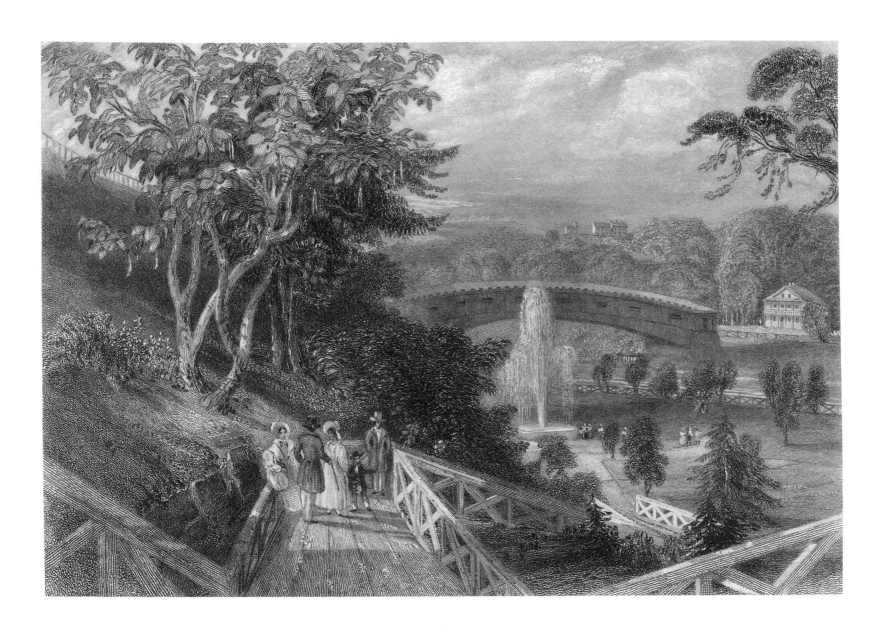

90. FAIRMOUNT GARDENS, WITH THE SCHUYLKILL BRIDGE

(PHILADELPHIA)

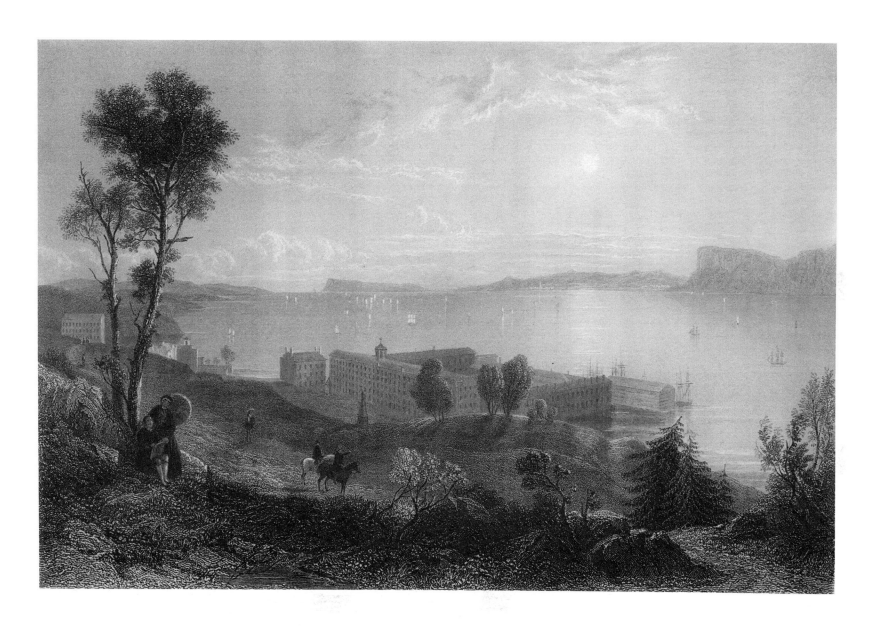

91. SING-SING PRISON, AND TAPPAN SEA

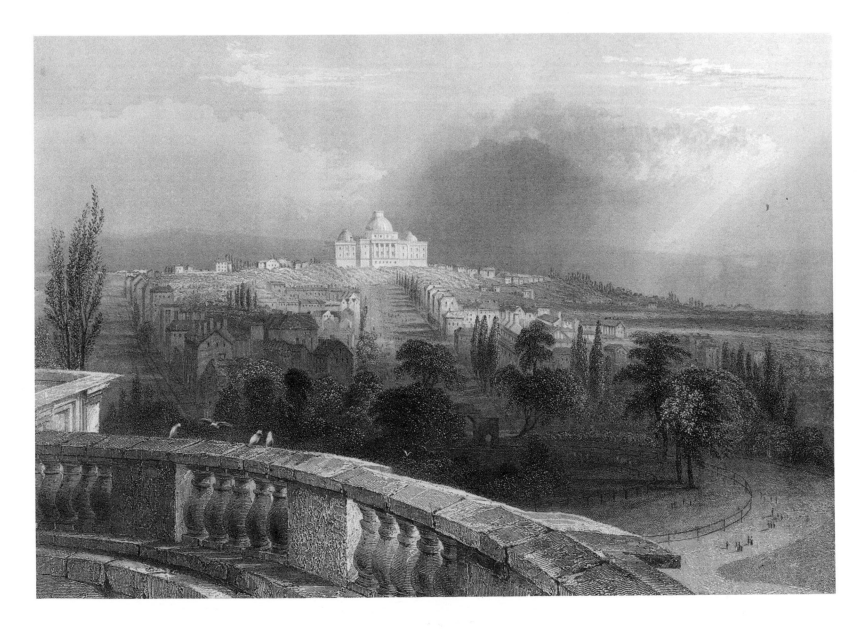

92. WASHINGTON, FROM THE PRESIDENT'S HOUSE

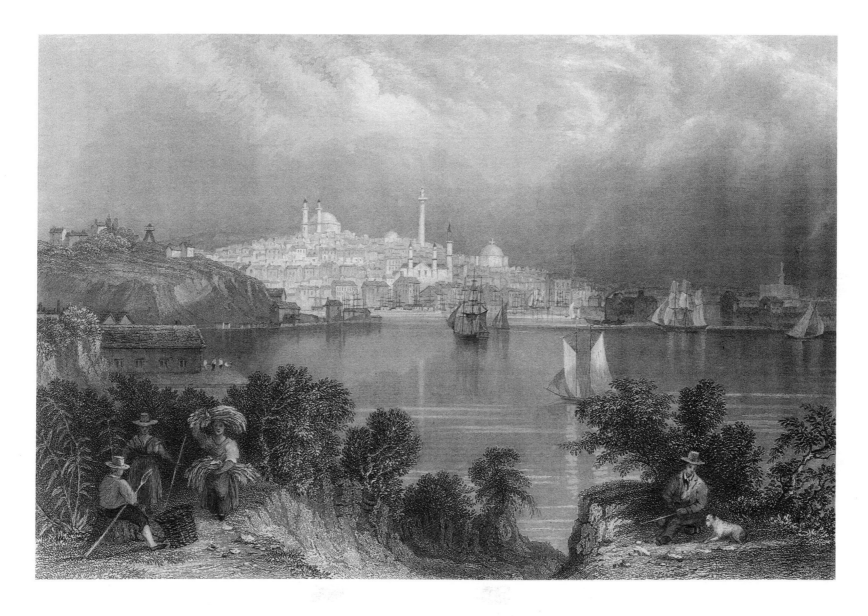

93. VIEW OF BALTIMORE

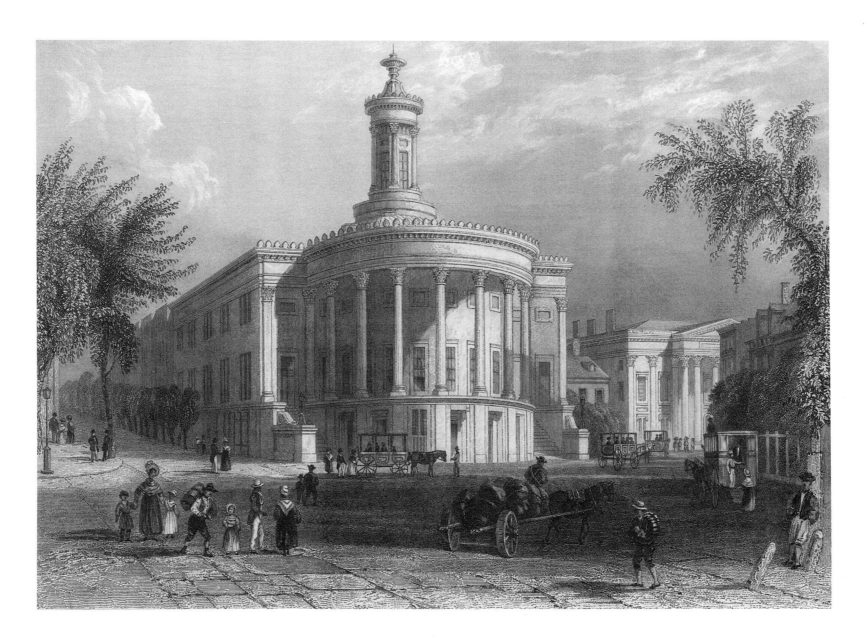

94. THE EXCHANGE, AND GIRARD'S BANK

(PHILADELPHIA)

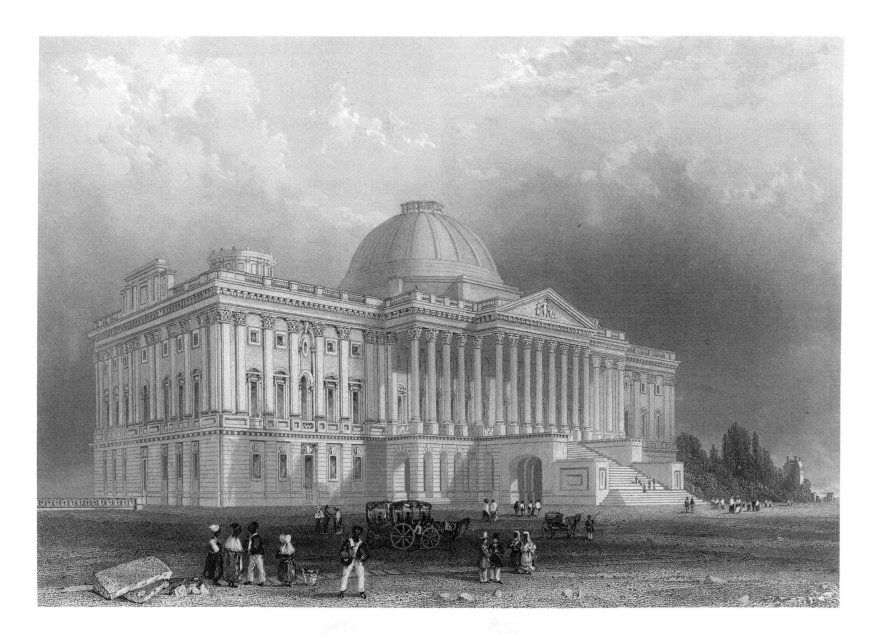

95. PRINCIPAL FRONT OF THE CAPITOL, WASHINGTON

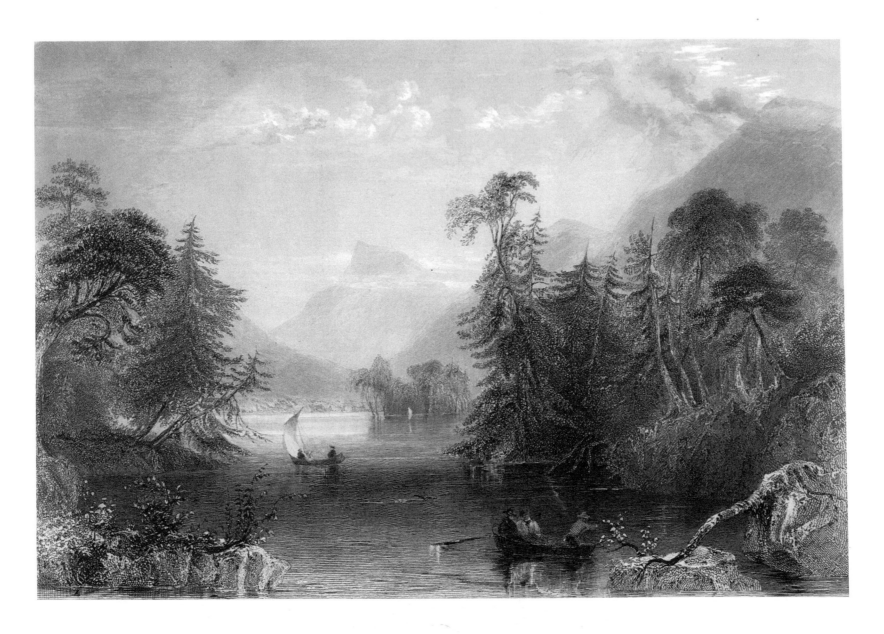

96. THE NARROWS, LAKE GEORGE

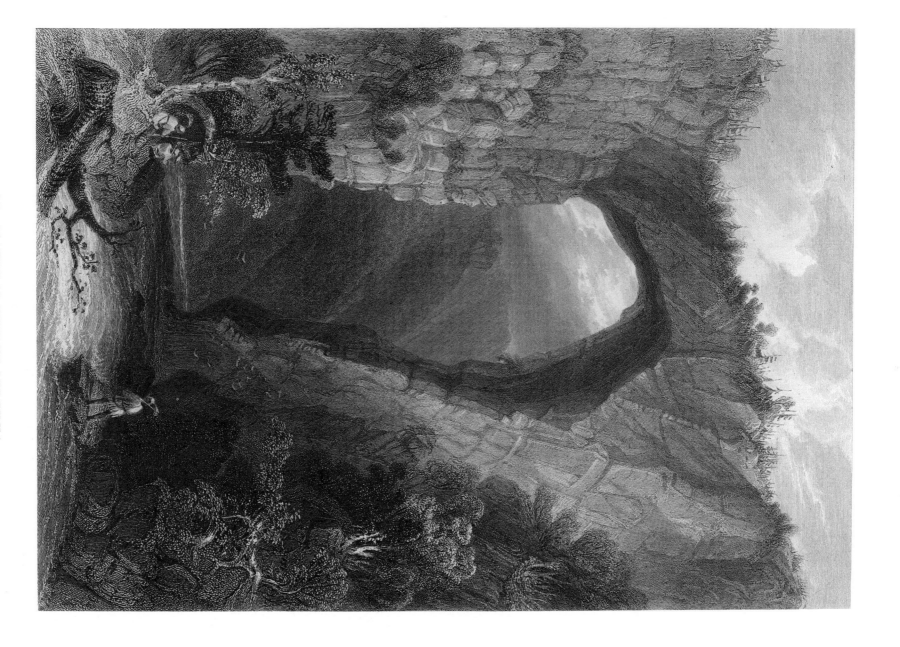

97. NATURAL BRIDGE, VIRGINIA

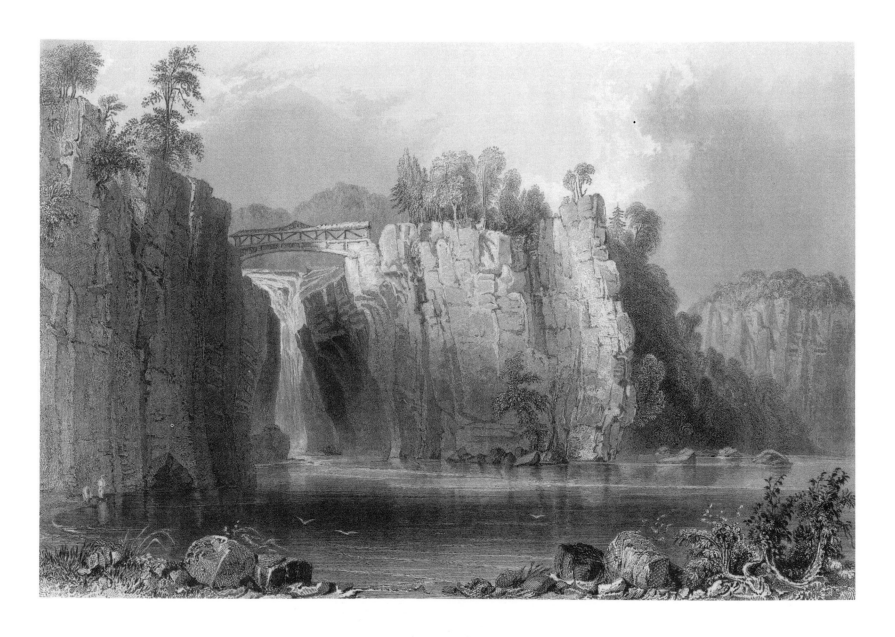

98. VIEW OF THE PASSAIC FALLS

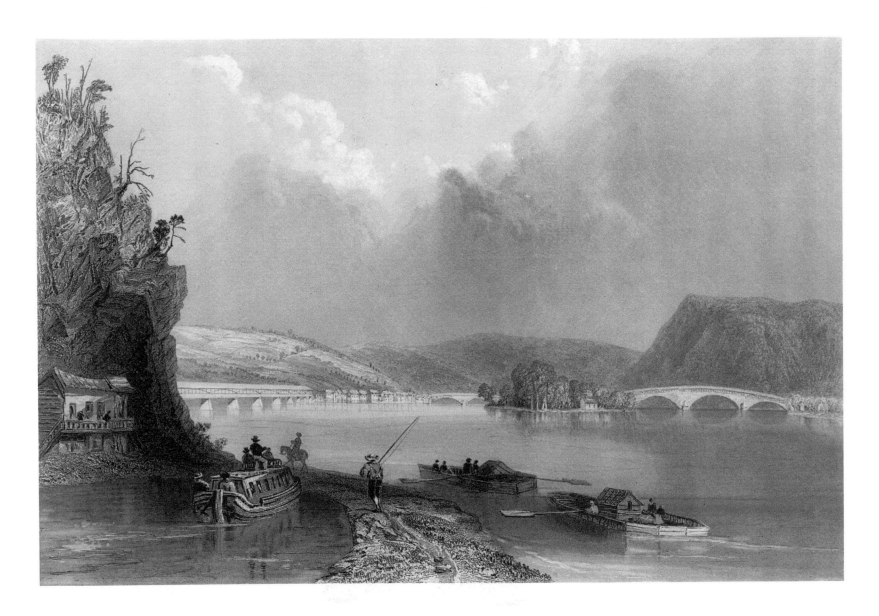

99. VIEW OF NORTHUMBERLAND

(ON THE SUSQUEHANNA)

100. PULPIT ROCK
(WHITE MOUNTAINS)

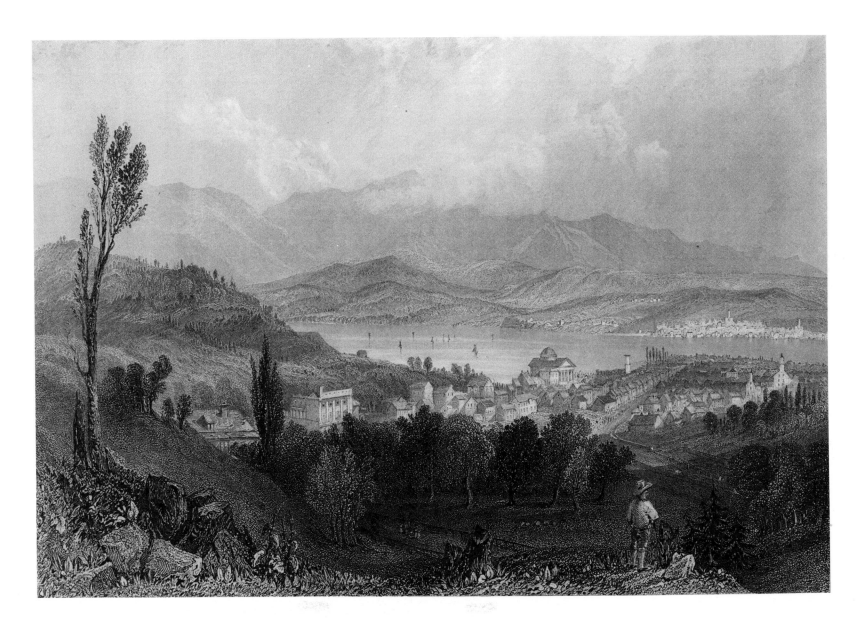

101. VIEW OF HUDSON CITY, AND THE CATSKILL MOUNTAINS

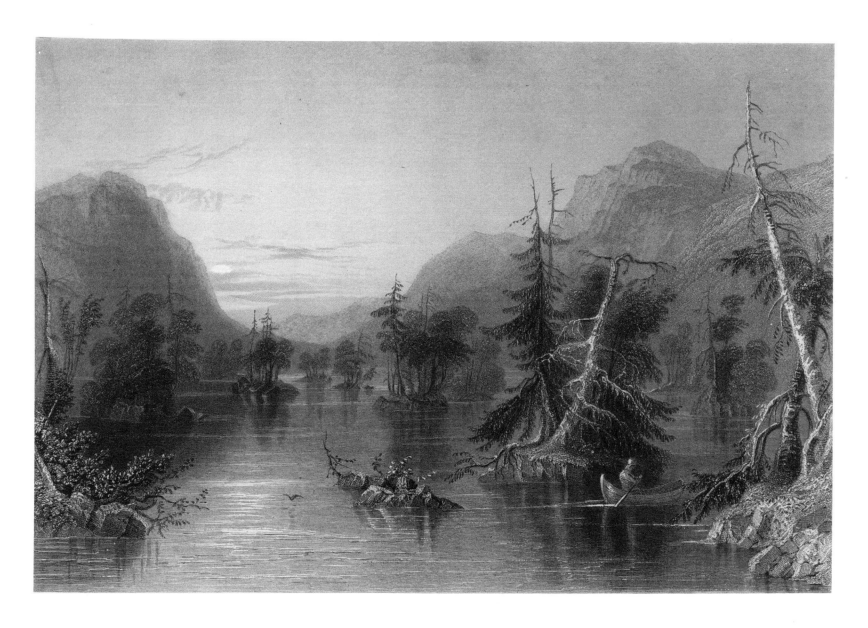

102. SCENE AMONG THE HIGHLANDS ON LAKE GEORGE

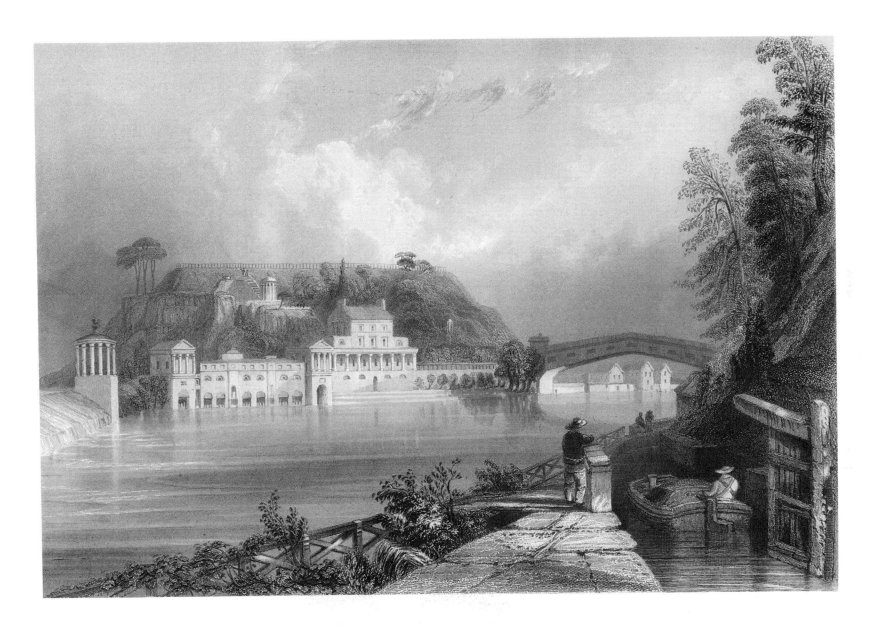

103. SCHUYLKILL WATER WORKS

(PHILADELPHIA)

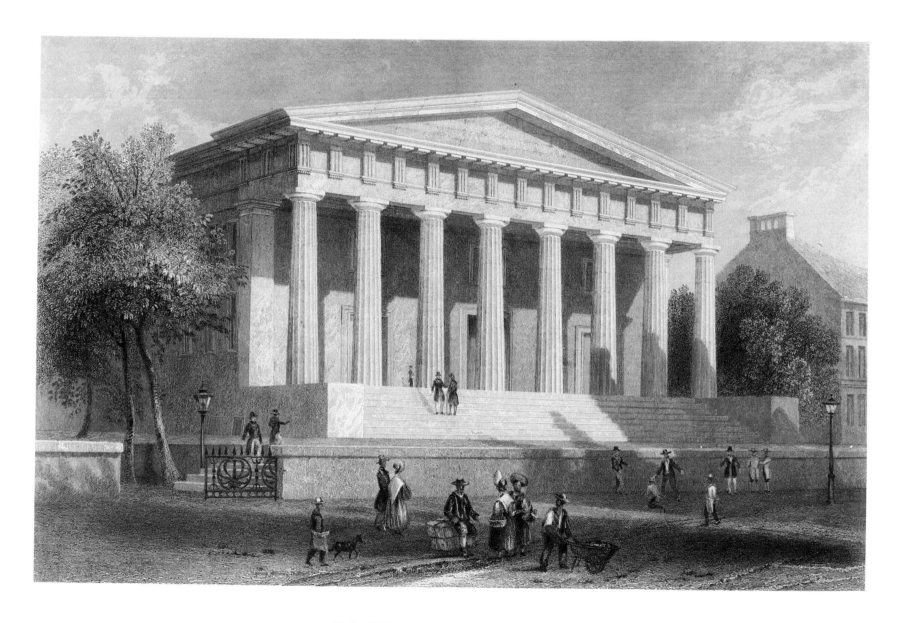

104. THE UNITED STATES BANK

(PHILADELPHIA)

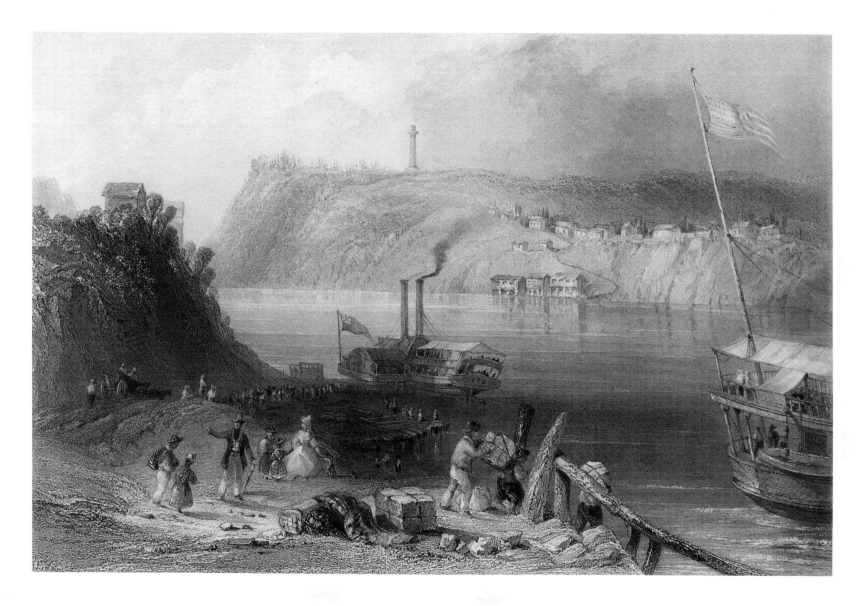

105. BROCK'S MONUMENT

(FROM THE AMERICAN SIDE)

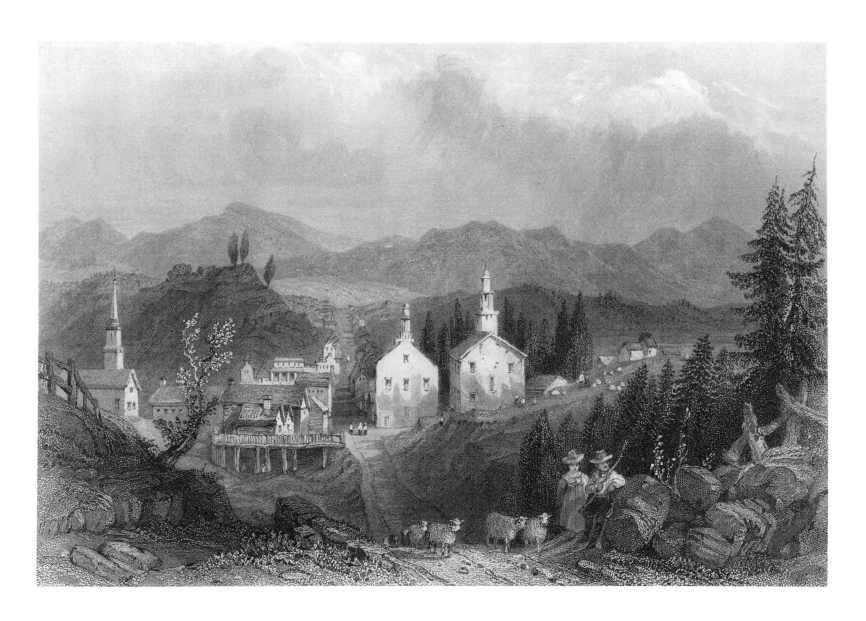

106. VILLAGE OF CATSKILL

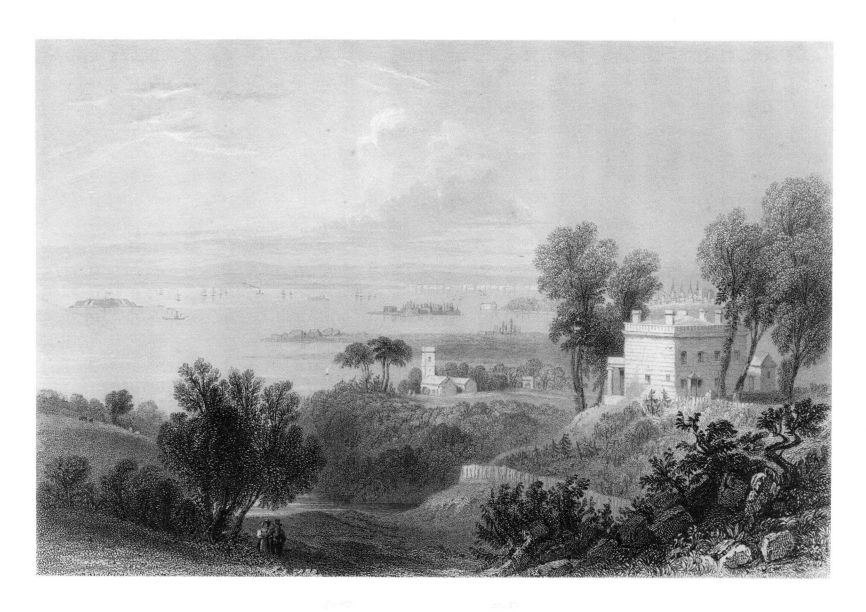

107. VIEW FROM GOWANUS HEIGHTS, BROOKLYN

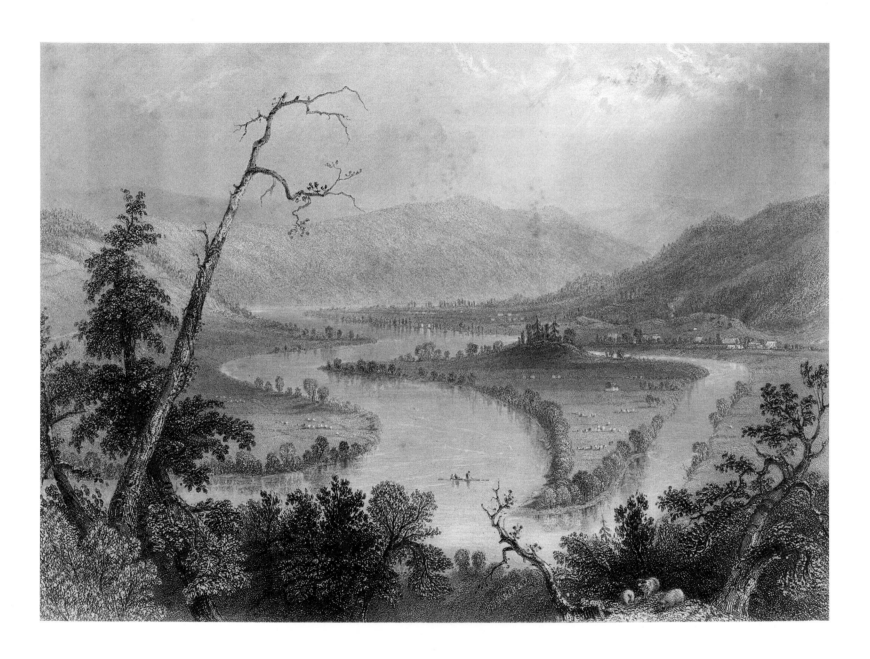

108. VIEW ON THE SUSQUEHANNA

(ABOVE OWEGO)

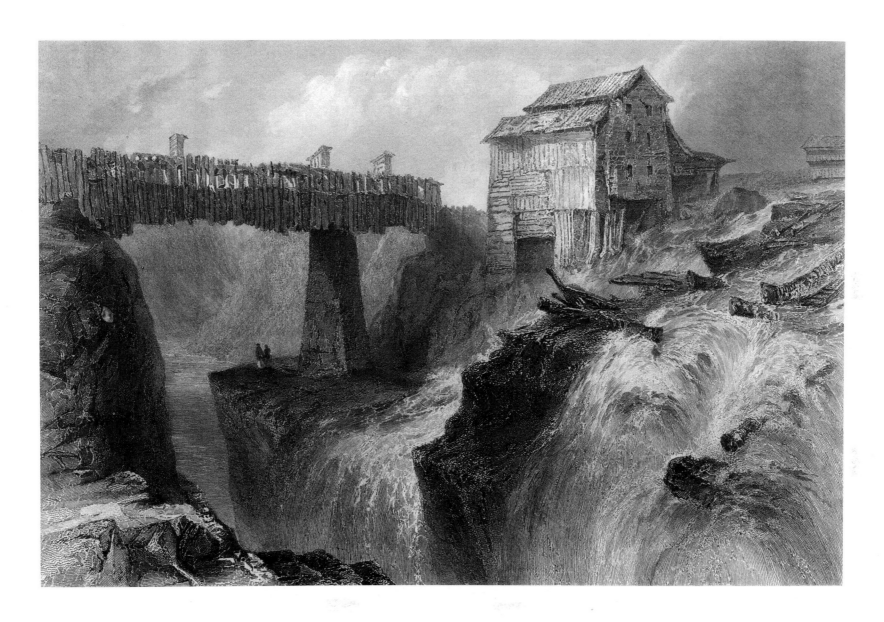

109. BRIDGE AT GLENS FALLS

(ON THE HUDSON)

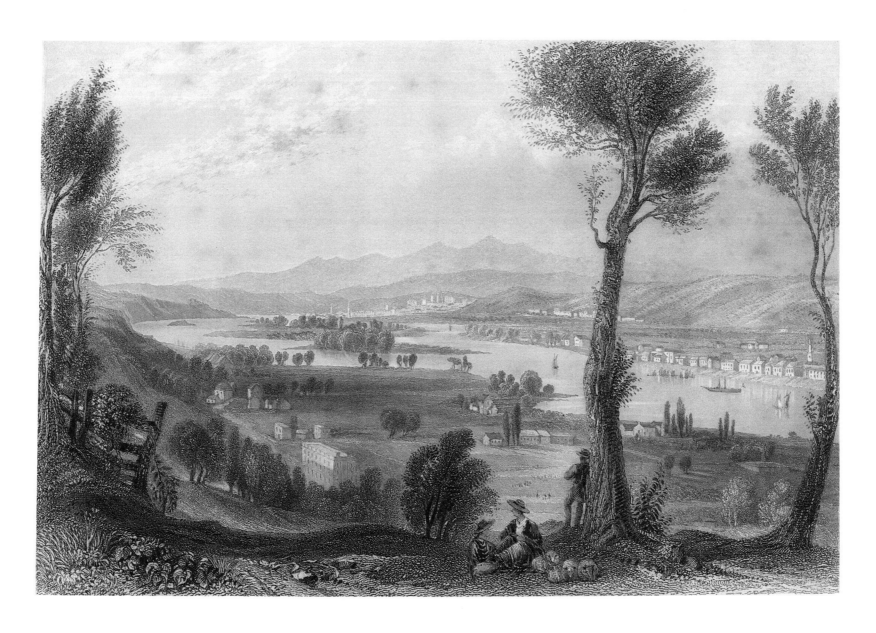

110. VIEW FROM MOUNT IDA, NEAR TROY

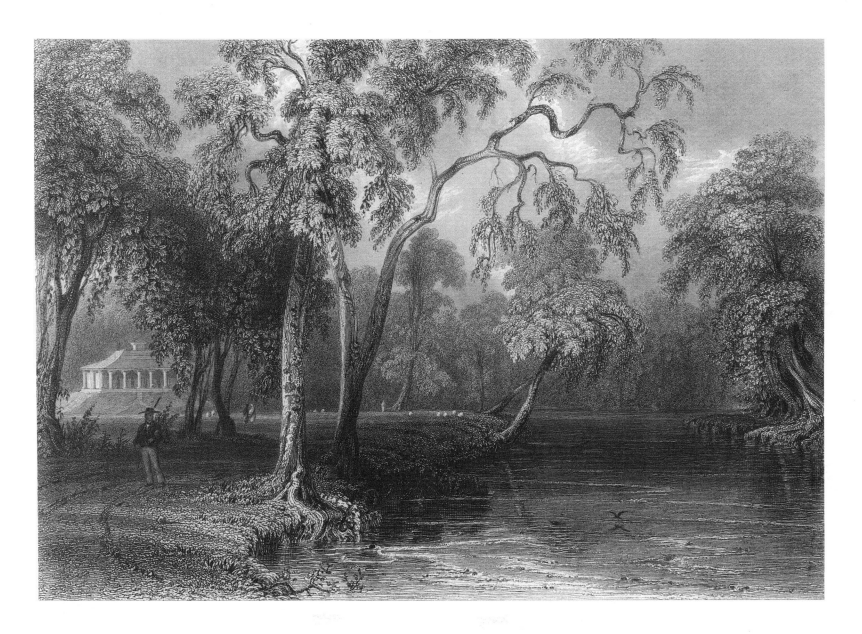

111. VIEW FROM GLENMARY LAWN

(ON OWEGO CREEK)

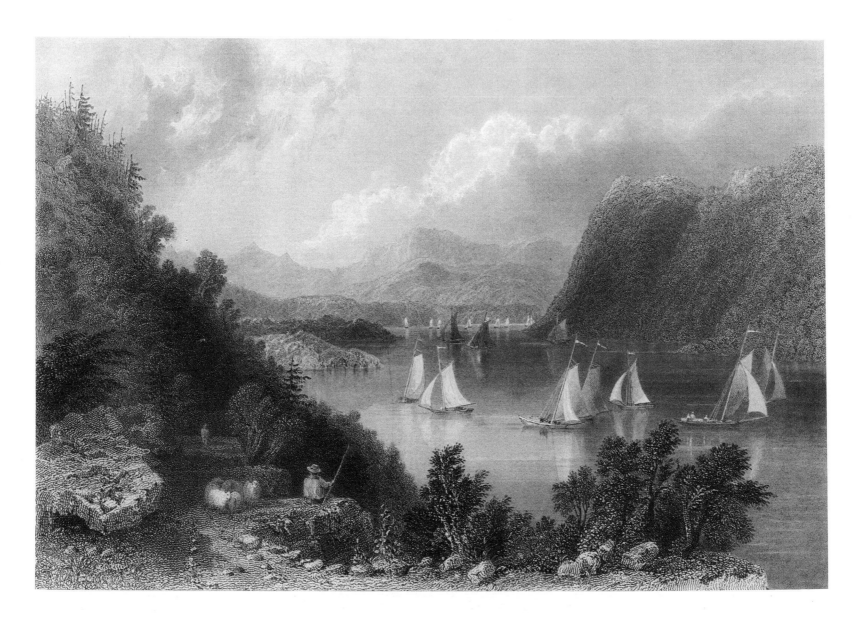

112. VIEW NEAR ANTHONY'S NOSE

(HUDSON HIGHLANDS)

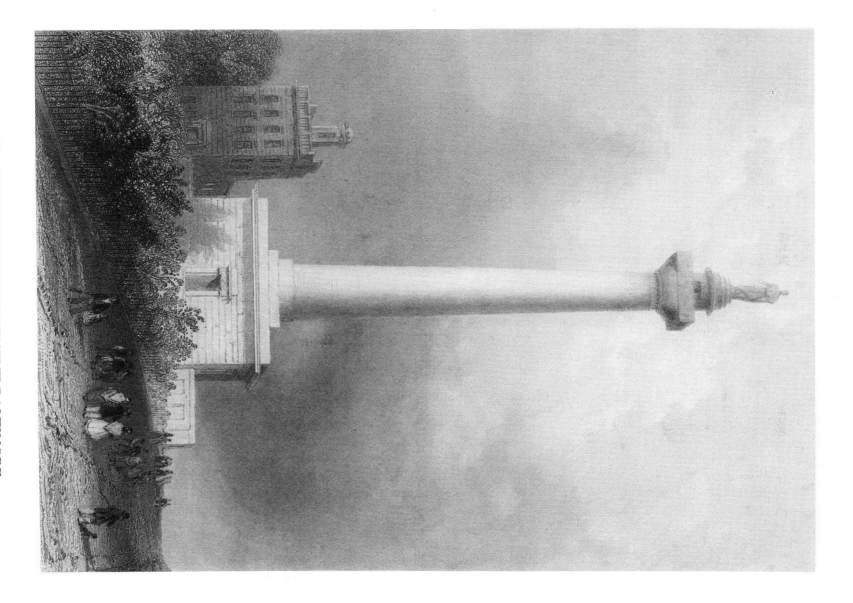

113. WASHINGTON'S MONUMENT, BALTIMORE

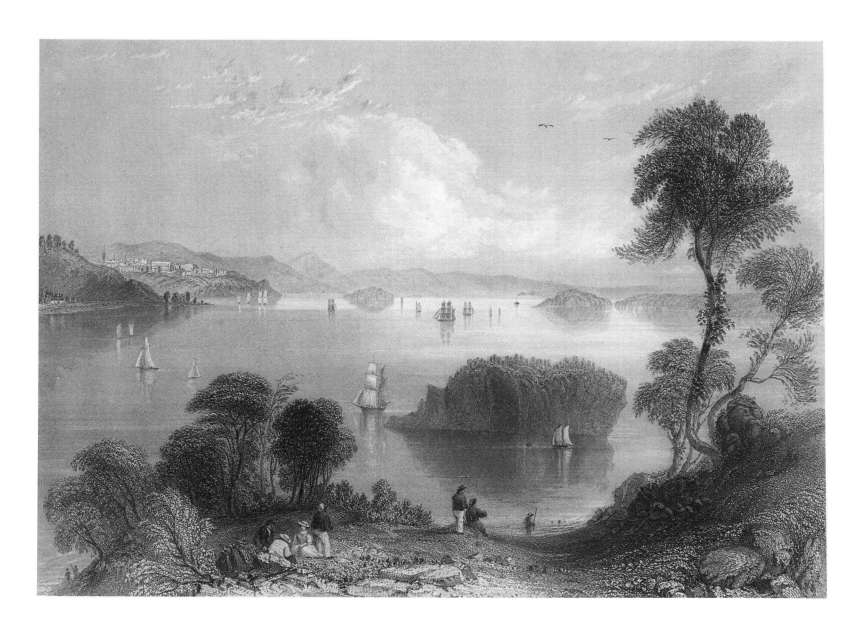

114. EAST PORT, AND PASSAMAQUODDY BAY, MAINE

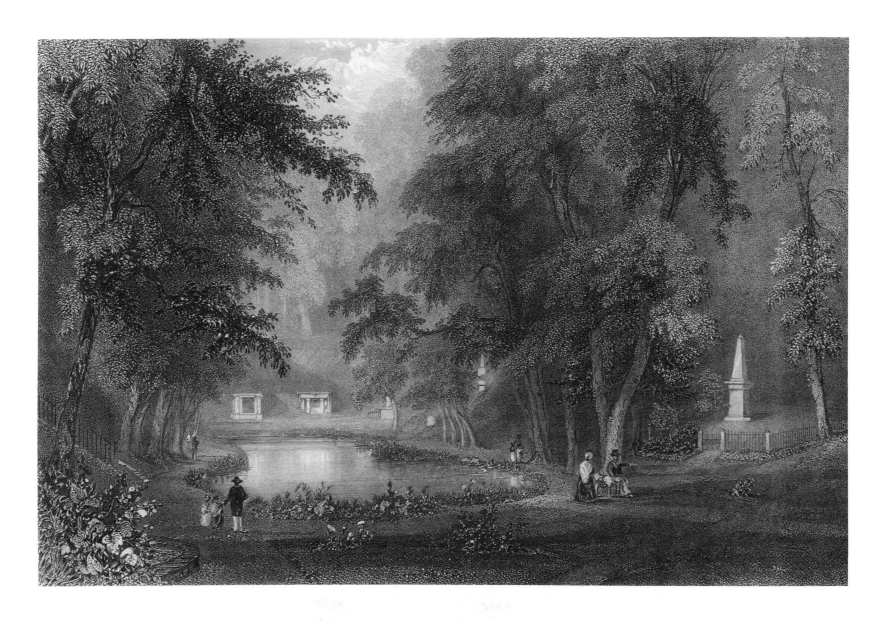

115. CEMETERY OF MOUNT AUBURN, CAMBRIDGE

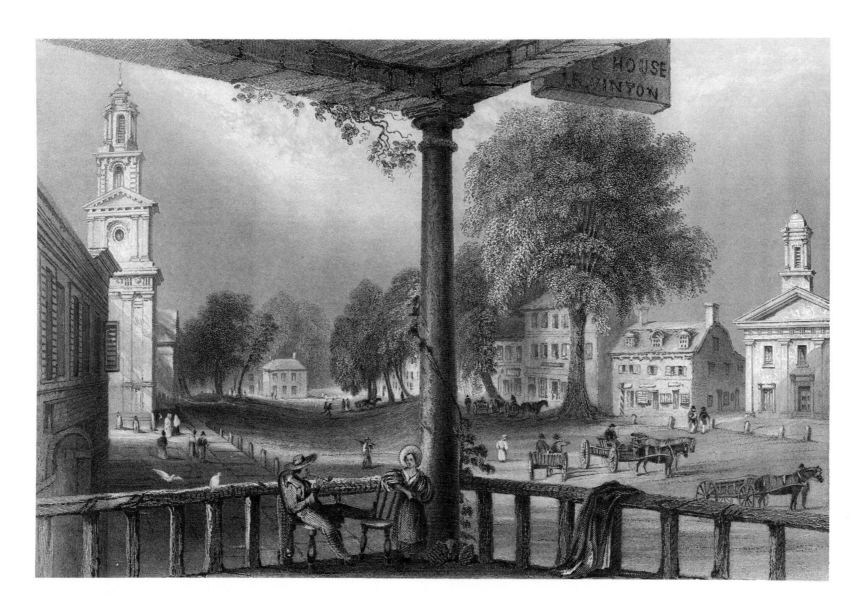

116. NORTHAMPTON, MASSACHUSETTS

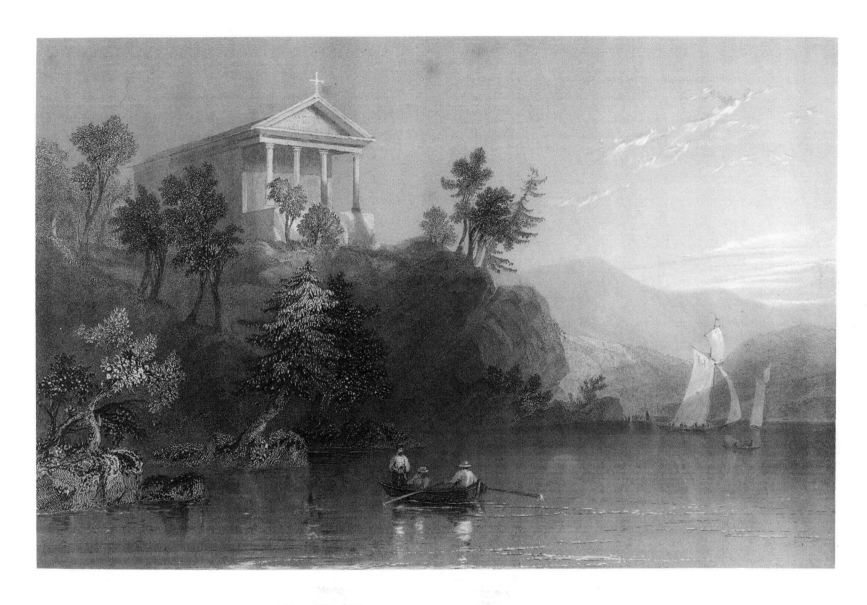

117. CHAPEL OF OUR LADY OF COLDSPRING

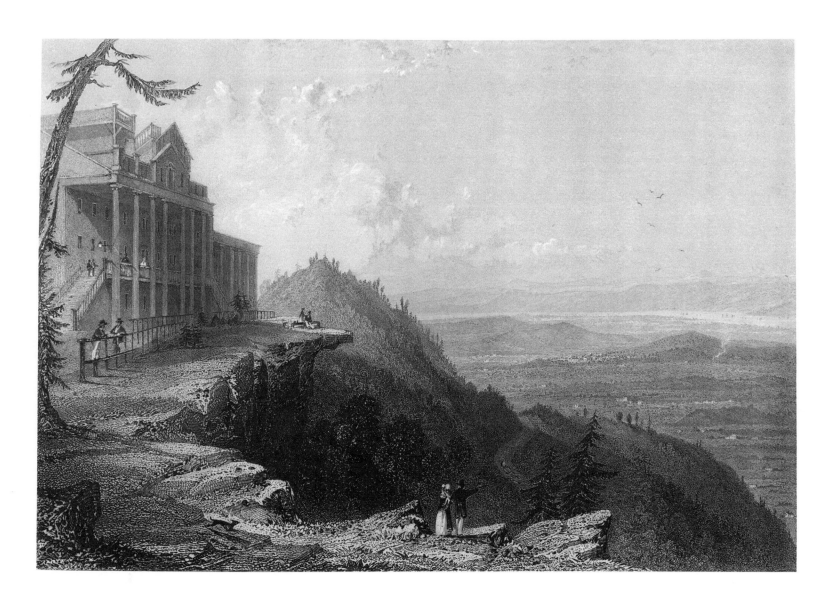

118. THE MOUNTAIN HOUSE, ON THE CATSKILLS

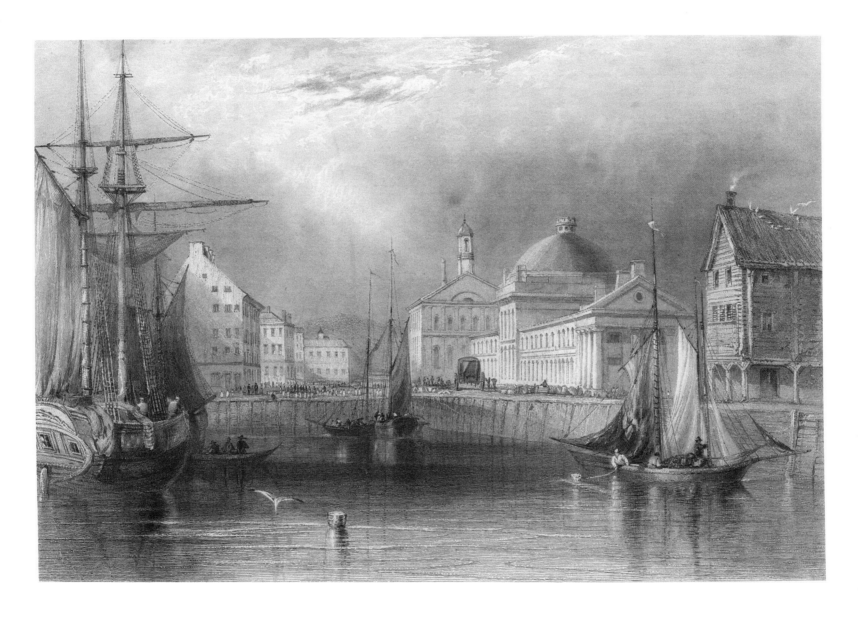

119. FANEUIL HALL, BOSTON, FROM THE WATER